HAVEN

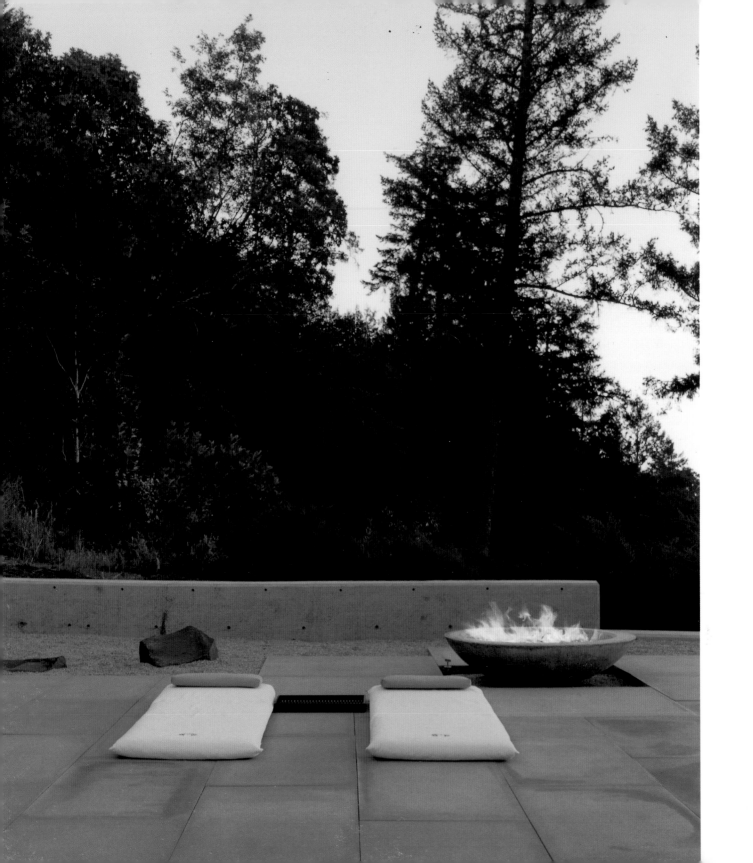

HAVEN | Cozy Hideaways and Dream Retreats

By Allison Serrell

Photographs by Meredith Heuer

CHRONICLE BOOKS

SAN FRANCISCO

Text copyright © 2005 by Allison Serrell

Photographs copyright © 2005 by Meredith Heuer

Library of Congress Cataloging-in-Publication Data available.

ISBN: 0-8118-4467-6

Designed by Jacob T. Gardner
Typeset in Miller and Trade Gothic

Photographs printed by Hong Color, NYC
Manufactured in Hong Kong.

Distributed in Canada by Raincoast Books
9050 Shaughnessy Street
Vancouver, British Columbia V6P 6E5

10 9 8 7 6 5 4 3 2 1

Chronicle Books LLC
85 Second Street
San Francisco, California 94105

www.chroniclebooks.com

Introduction

Why has the idea of escape become so cherished?

Perhaps because, in this fast-track world, we all yearn to slow down. Unplug. Breathe. Let's face it, life has gotten complicated. The workday has grown longer; the static in our lives has threatened to take over. There are endless cable channels to choose from, but everyone agrees there's not much worth watching. We have multiple phones, a longer list of e-mails, calendars that are chock-full of appointments and meetings. We get less sleep; we endure more stress.

A haven, whether cozy or expansive, rustic or grand, can restore its residents to a state of grace. Many of us long to move away from the worries of everyday life. We dream of smaller towns, country villages, seaside locales, or deep woods where we will find quiet, peace. An escape to a haven is a retreat from the demands of work, traffic, noise, the crowds at supermarkets, and big-box stores.

The hideaways and retreats in *Haven* are situated in places where noise dissipates; trees appear. These havens connect their residents to quiet, to nature: a little cabin in the woods; a breezy, sunny cottage; a bungalow by the sea. From a tucked-away place for little more than a tent to a luxurious home in a verdant valley, the places here are undeniably set apart and private—places where their inhabitants hear the rhythmic sounds of the ocean or the gurgling of a creek instead of the thrum of the freeway. Here one can smell the fragrance of summer rain or the salt of the sea, walk barefoot through a meadow with no agenda but to find that ideal picnic spot that has both sun and shade.

These structures celebrate the sensation of simply being away from it all, escaping to a private world. They honor simple living with their proximity to nature and their use of natural materials. Their proportions are modest, but light and views are plentiful, and comfort is king.

These houses are privately owned (with the exception of two intimate inns); all reflect the personal sensibility of their inhabitants and offer infinite inspiration to those planning their own escape. These spots are remote, yet full of possibility: they are places to rest, recharge, and bask in the calm, simplified world of long walks in a meadow, swimming in a private pond, reading in a hammock. After all, simplicity is a recipe for relaxation. One can take enormous pleasure in building a fire and stoking it throughout the evening. And there is no more calming ritual than sitting on the deck and watching the sun rise while nursing a pot of tea.

Perhaps perusing these pages will be a retreat unto itself, the chance to dream of a simpler, quieter life in which to reconnect with nature—and oneself.

Country Cabin

Completely secluded within a wooded grove, this early-twentieth-century summer cabin, originally built as a sportsman's lodge, has a timeless, woodsy appeal. Shingled cedar siding signals a seamless integration with nature; a fence made of cypress logs adds to the rustic feel. Inside, wide plank floors, wood-beamed ceilings, and detailed paneling provide classic charm.

The cabin epitomizes grown-up coziness. Deep-cushioned leather furnishings surround the massive fireplace, which invites gatherings around the hearth. A dining alcove, or inglenook, is outfitted with wool pillows for intimate meals by the window. The separate bedroom, accessed via heavy redwood doors, feels like a feathered roost with a high, king-size bed and plenty of soft linens and pillows. Here, the smell of timeworn wood mingles with the fresh air, fragrant with cypress. A sense of old-fashioned comfort prevails—there are no televisions, stereos, or computers to compete with the simple allure of cabin living.

The cabin's decor speaks of outdoor pleasures: the deer head mounted above the fireplace suggests the place's history as a hunting and fishing lodge; fishing equipment propped against a landscape painting brings out the would-be fly fisherman within. A deck off the front of the cabin is ideal for a post-hike lemonade or an afternoon with the crossword puzzle.

Built in 1900, the cabin reflects the tenets of the arts and crafts movement, a popular architecture and design style of the period. The decor symbolizes a reverence for craftsmanship and natural materials, with minimal embellishment and a preponderance of wood. Exposed ceiling rafters and prominent crossbeams on the bedroom doors are classic arts and crafts details. Wherever possible, local materials were used: fencing of salvaged cypress, shingles and flooring of indigenous cedar, redwood board-and-batten paneling inside. A massive handcrafted fireplace, made of ocean rocks salvaged from beaches nearby, gives the cabin a solid grounding. Iron and mica lanterns offer a beautiful amber glow matched by the flickering fire from the hearth; leather and wool add soft touches throughout.

For luxurious bathing, a vintage two-person soaking tub anchors the generous bathroom, where thick towels and soothing white walls allow for deep relaxation within this wonderfully woodsy retreat.

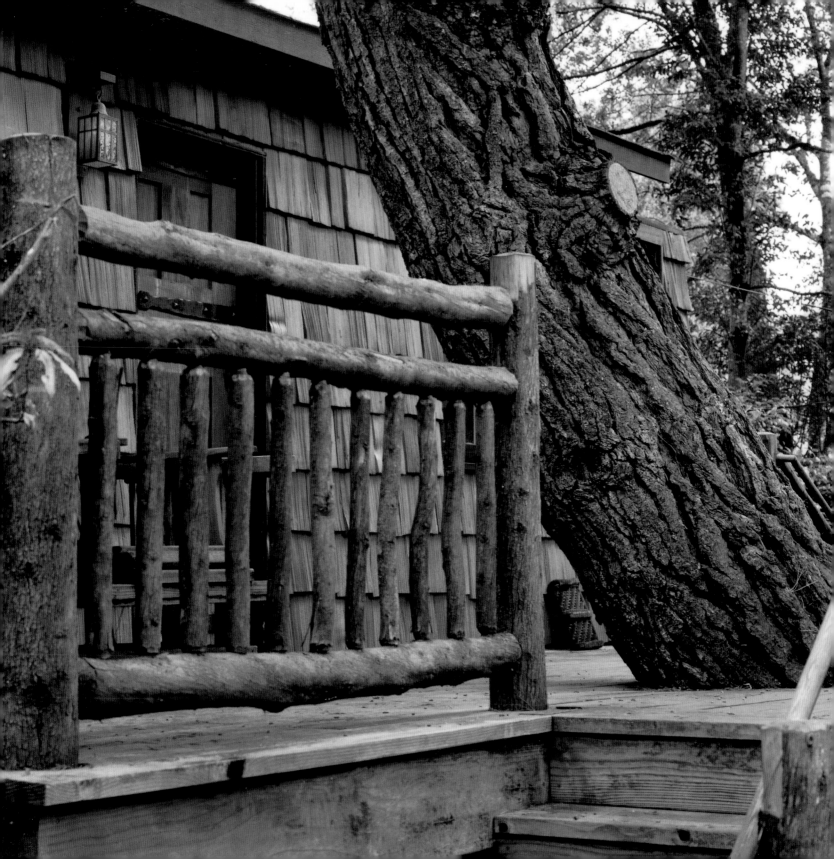

CABIN COMFORT

There is perhaps no more soothing a refuge than a rustically elegant country cabin. To outfit your own, consider the following niceties for comfort and style:

::: WOOLEN PLAID BLANKETS FROM PENDLETON OR ARMY-NAVY STORES

::: WORN LEATHER CHAIRS FOR READING BY THE FIRE

::: PAINTINGS, SOUVENIRS, OR MEMORABILIA THAT SUGGEST THE OUTDOORS

::: FOR THE FIREPLACE: DRY WOOD, KINDLING, NEWSPAPERS, LONG MATCHES, AND FIRE IRONS FOR STOKING

::: LOCAL HIKING GUIDES, MAPS, AND A COMPASS

::: BEAR- OR SHEEPSKIN RUG BY THE BED OR FIREPLACE

::: EXTRA SWEATERS AND OUTDOOR GEAR, SUCH AS WELLINGTONS, FOR GUESTS

A common feature of arts and crafts houses, an inglenook (opposite, bottom right) is a built-in wooden seat traditionally used in English homes and cottages in the seventeenth century. It was originally designed to flank a large fireplace to provide seating by the hearth. The design was reintroduced in the late nineteenth century for more decorative purposes. Fishing gear (right) awaits the angler, while the spacious deck (opposite, left) offers leisurely respite for those who stay behind.

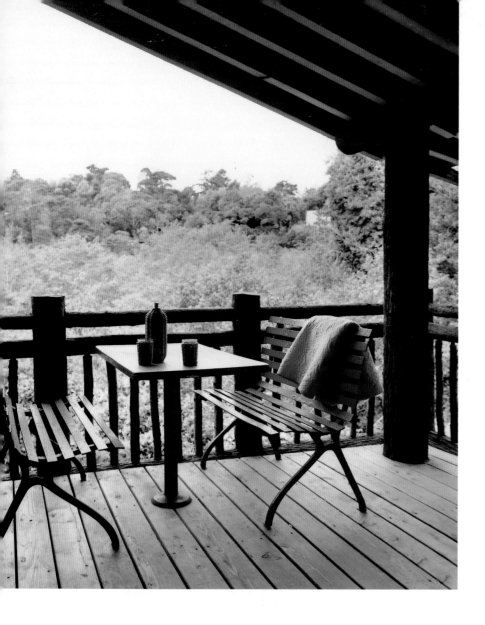

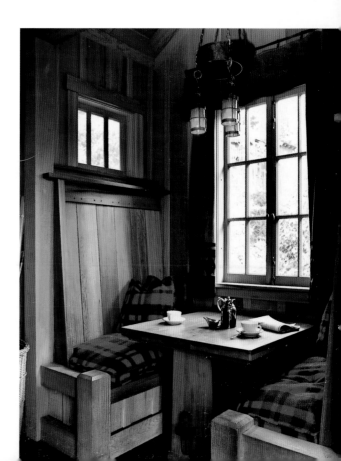

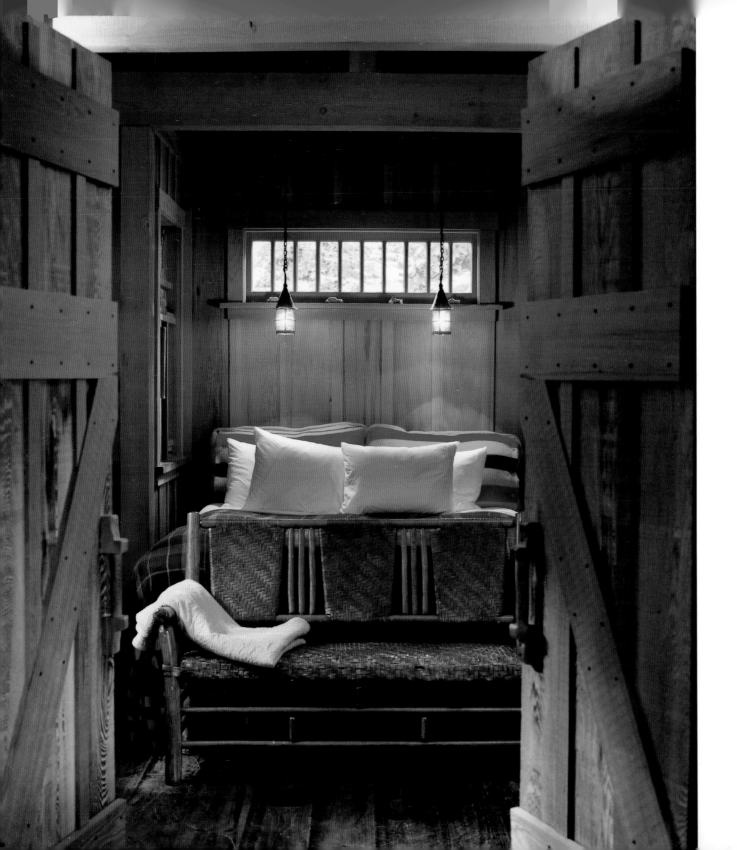

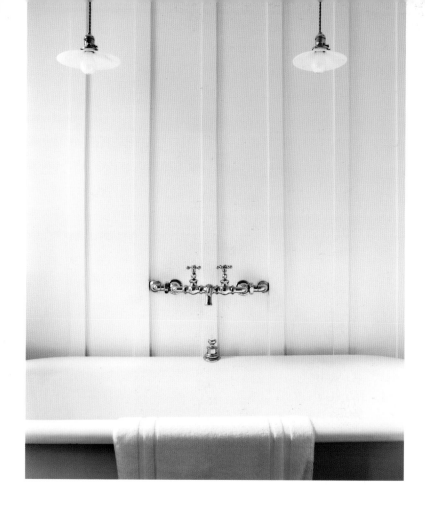

The bedroom (opposite) is a sequestered nook with built-in bookcases and warm redwood paneling. Exposed crossbeams on the doors are a common element of arts and crafts design, which celebrates craftsmanship and the use of everyday materials. An oversize tub (left) and vintage medical cabinet (below) give the generous bathroom a soothing feel.

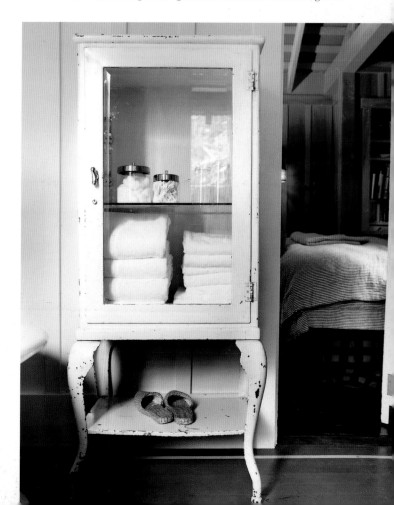

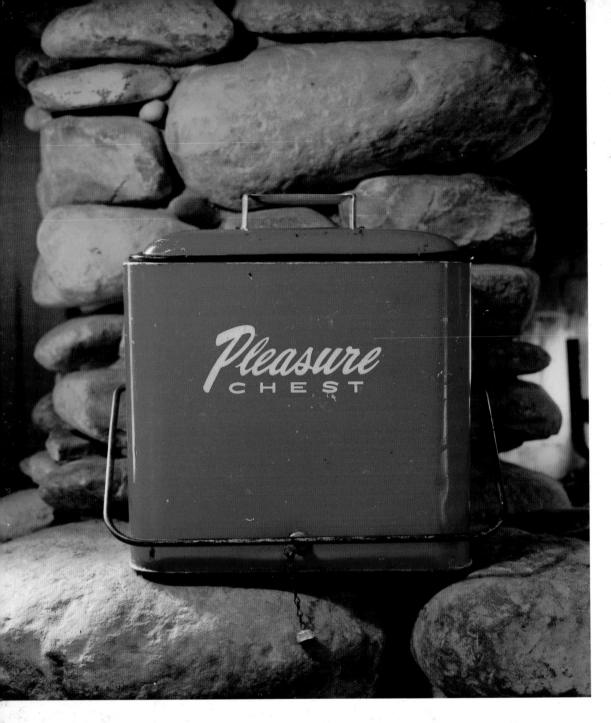

A vintage cooler (above) sets an old-fashioned tone in this time-honored cabin.

The large living area (opposite) is dominated by an oversize hearth crafted from salvaged ocean rock. Exposed roof rafters fit in with the Craftsman design aesthetic.

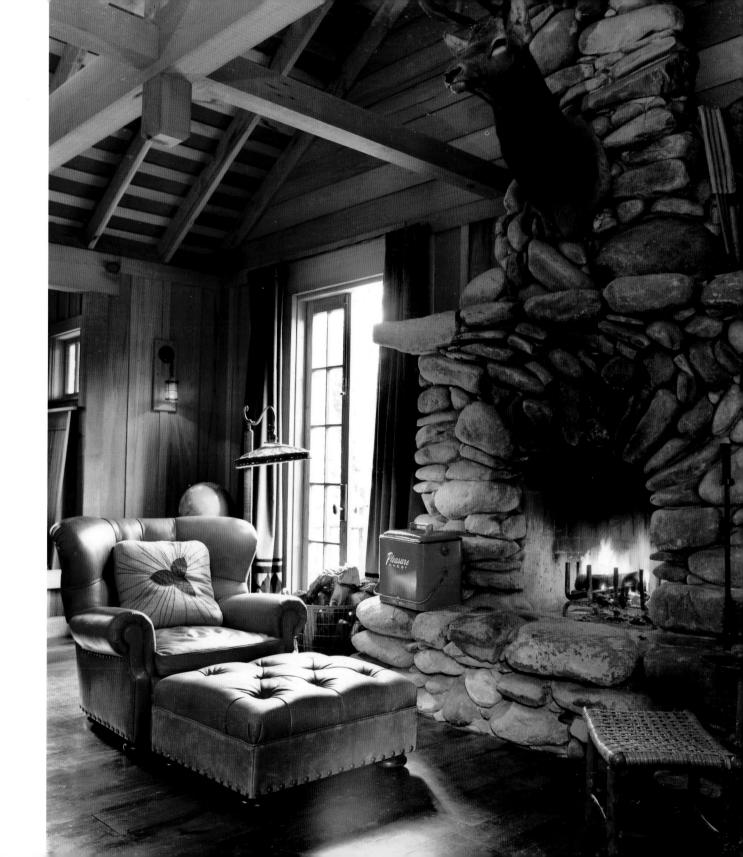

A Taste of the Tropics

When the weather heats up, time slows down; the pace of life slackens. And when a retreat means a sojourn to a hot-weather clime, we shed our everyday concerns to relish the sun, a swim, a nap in the shade. It's the ultimate change in routine: we swap computers for canoes, suits for sarongs, sandwiches-on-the-go for grilled mahi-mahi and a margarita.

At this tropical getaway, everything you see signals languorous, sensual living. The low-slung architecture doesn't compete with the terrain; natural materials create soothing surroundings. The adobe-style house, made of tinted cement, is shaded with natural palapas made from the leaves of palm trees on the property. The walkways are carved from irregularly cut slate to give a natural, wabi-sabi elegance. Walls are thick for

a quiet, cooling effect, the perfect environment for a siesta. Landscaping is lush but utterly natural, with native plants and crushed gravel setting the tone. The buildings' thatched roofs put one squarely in mind of the Caribbean, where good living gets its name.

Inside, light prevails through the copious windows, and furnishings are kept simple and rustic. Beamed ceilings and tiled floors have an easy-to-maintain, unfussy feel. A wrought-iron bed is dressed in crisp sheets; French doors nearby invite nighttime breezes. A beautiful old chaise in the living room says relaxation reigns. Outside, a handmade pine table, similar to those found at tavernas in Greece, is matched with folding chairs; the seating area is shaded by a palapa roof.

Time spent at this retreat is precious and never pressured. An early morning swim followed by a game of backgammon by the pool, a lunch of fresh tropical fruit enjoyed outside, a hike in the surrounding mountains, or an afternoon game of bocce, followed by lazy stargazing at night—that's what this hideaway is all about. Activity is centered around a gorgeous negative-edge pool; trips in and out of the water are easily interspersed with naps and meals. No need to change out of your swimsuit—the less encumbered you are, the better.

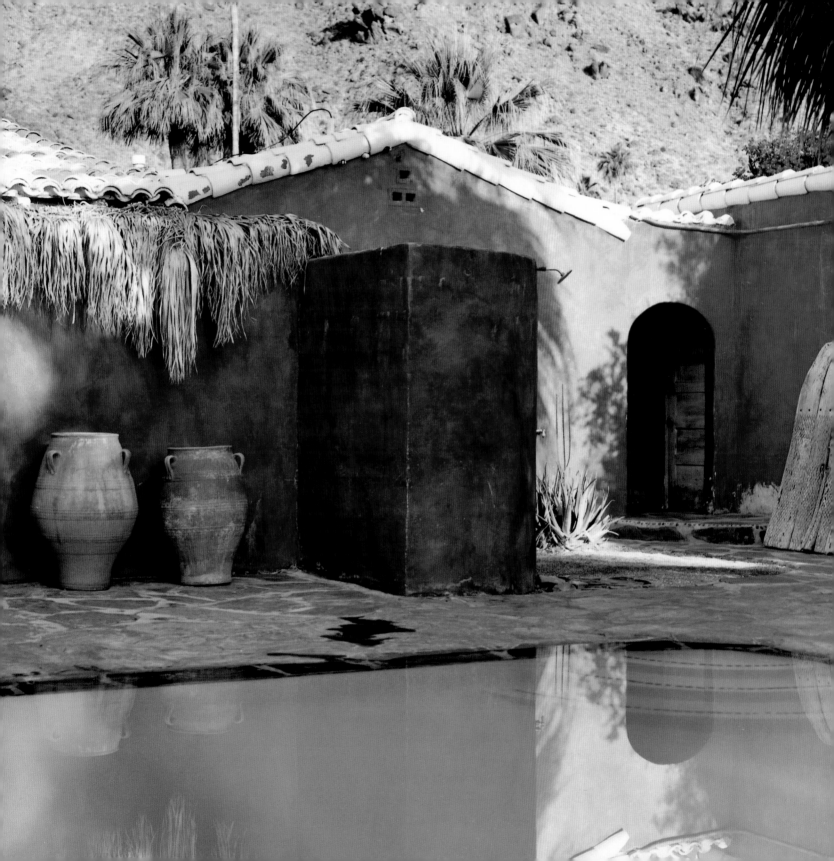

GOING NATURAL

Natural materials go a long way toward creating a cooling, soothing
hideaway in which to soak up the sun or rest in the shade.

::: THICK ADOBE-STYLE WALLS KEEP THE TEMPERATURE
 DOWN INDOORS.

::: NATURAL STONE AND SLATE ON THE FLOORS ADD TO THE
 COOLING EFFECT.

::: NATIVE PLANTINGS PROVIDE LUSHNESS AND SHADE.

::: WOVEN RATTAN CHAIRS DON'T ABSORB HEAT AND CAN BE
 USED INDOORS OR OUT.

::: WHITE COTTON CURTAINS CUT DOWN ON GLARE.

::: CRISP LINEN SHEETS BREATHE WELL AND ARE COOL TO THE TOUCH.

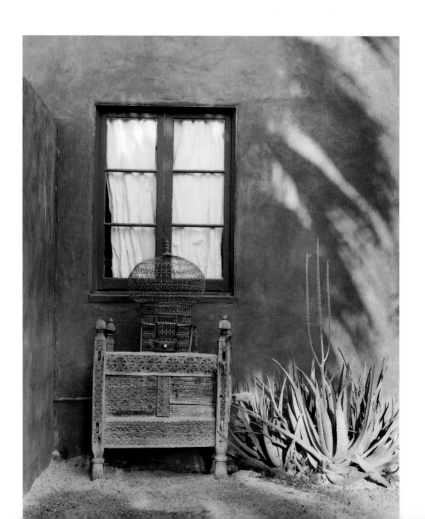

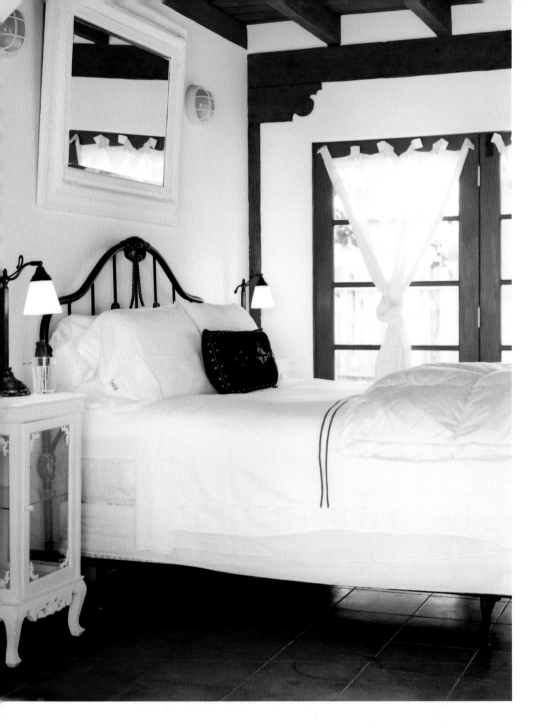

The bedroom (above and right) in this tropical hideaway is outfitted with materials to keep things cool: thick stucco walls ensure lower temperatures inside, muslin curtains cut down on glare, crisp linen sheets breathe well, double doors leading outside permit cooling breezes.

A rustic chic aesthetic is enhanced by lush plantings (opppsite).

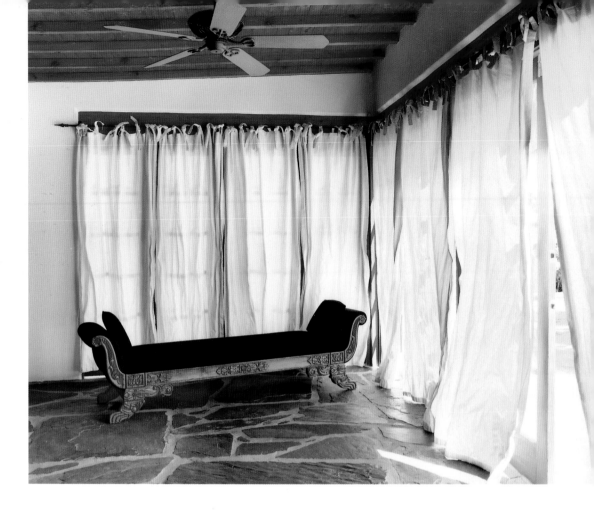

Few furnishings are needed when strong materials are used. A palapa (above, left), a thatched roof made of palm leaves, is a practical way to create shaded areas around the structure, and also softens the adobe look. Slate slabs give the sitting room (above, right) an established look. Muslin panels, in lieu of curtains, and rough stone countertops (right) add texture to the room.

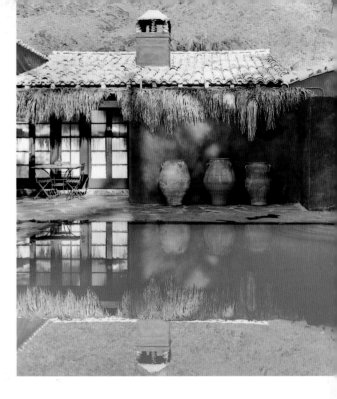

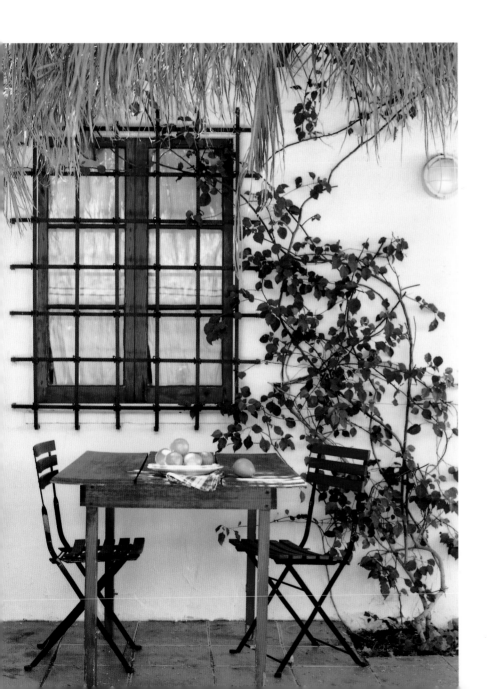

Textures provided by natural materials, rather than
fancy furnishings, give this getaway an alluring, sensual
feel. On the tile patio (left), a pine table in the style of a
Greek taverna is matched with Parisian garden chairs
to create the comfortable feel of relaxing in an outdoor
European cafe. The pool (above) is edged with large
slabs of cut slate.

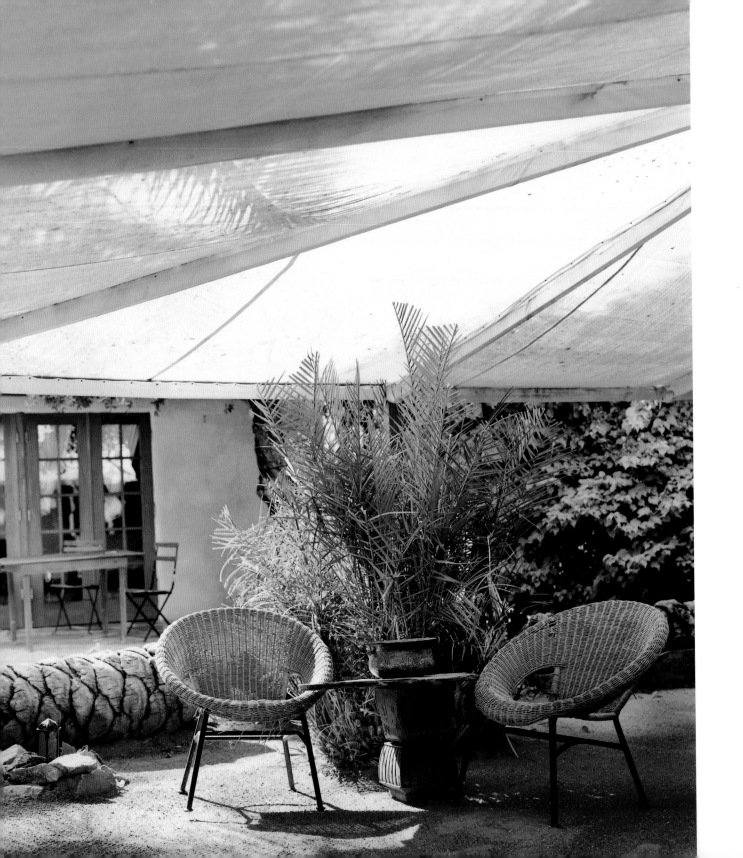

A simple vinyl tarp is hung outside for a shaded tentlike environment (opposite), furnished with indoor-outdoor rattan chairs. Much of the garden at this tropical retreat is paved in gravel rather than seeded with costly, high-maintenance lawn. It's the perfect setting for a bocce court (below), the favored pastime in the relaxed southern towns of Italy and France. To cut down on watering, the owner planted mostly native trees, including palms and citrus, which sweetly scent the air. The result is a welcoming spot for sportsmen and spectators alike.

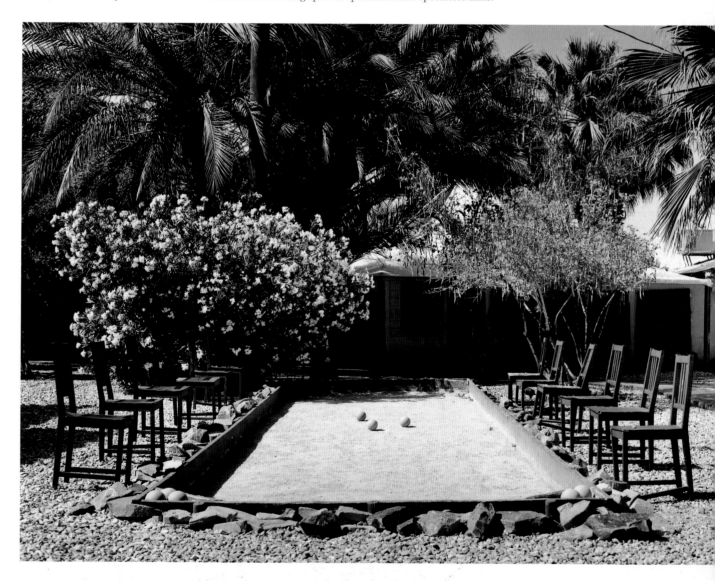

The Simple Life

Sometimes a house fits in so naturally with its surroundings that it seems to have sprouted from the land itself. This small wooden shack tucked into a hillside sits quietly on the land, making as minimal an impact as possible. The cozy dwelling, which consists of an enclosed bedroom, open kitchen, and wraparound deck, is a simple retreat. Built off the grid, it has no electricity or septic system. The owners rely on a self-composting toilet, lanterns, candlelight, and a small propane water heater for comfortable weekend living.

For reasons of cost and sustainability, the house is made almost entirely of recycled and salvaged materials. It is clad in stained plywood with repurposed redwood batting. The decking is recycled redwood. The interior trim and walls are rough-sawn spruce. The sloping metal roof is also practical, allowing for runoff of rain and debris from trees, while opening up the front of the house to the breathtaking view.

Siting for this simple house was crucial. It was placed facing south to take in the lush surroundings and under an oak tree for ample shade in summer. The house is miles from the nearest paved road, affording the utmost in quiet and privacy. With only four hundred square feet inside and out, the tidy cabin emphasizes the outdoors. The inside speaks of restraint and simplicity; the outside affords luxurious access to unspoiled nature. The deck has a spectacular 180-degree view of the surrounding verdant gorge.

The simple setup celebrates outdoor living. Meals are prepared in the open kitchen, with its small propane-powered burners, stainless-steel sink, and lovely old cast-iron stove salvaged from a nearby barn. The fifty-acre site was chosen for its old oak tree, under which the owners have created an outdoor room of sorts, with a picnic table, grill, hammock, and even a big sofa for lounging or napping. Nearby is a small pond for fishing or swimming in summer.

The bedroom provides the most shelter, with floor-to-ceiling French doors opening onto the deck on two sides. The small room accommodates all the necessities: a queen bed, closet, and chests of drawers. Off the bedroom is a little privy, beyond which is an open-air shower. Here, there is little need for curtains, and in the morning, the sun's warm rays are a gentle alarm clock.

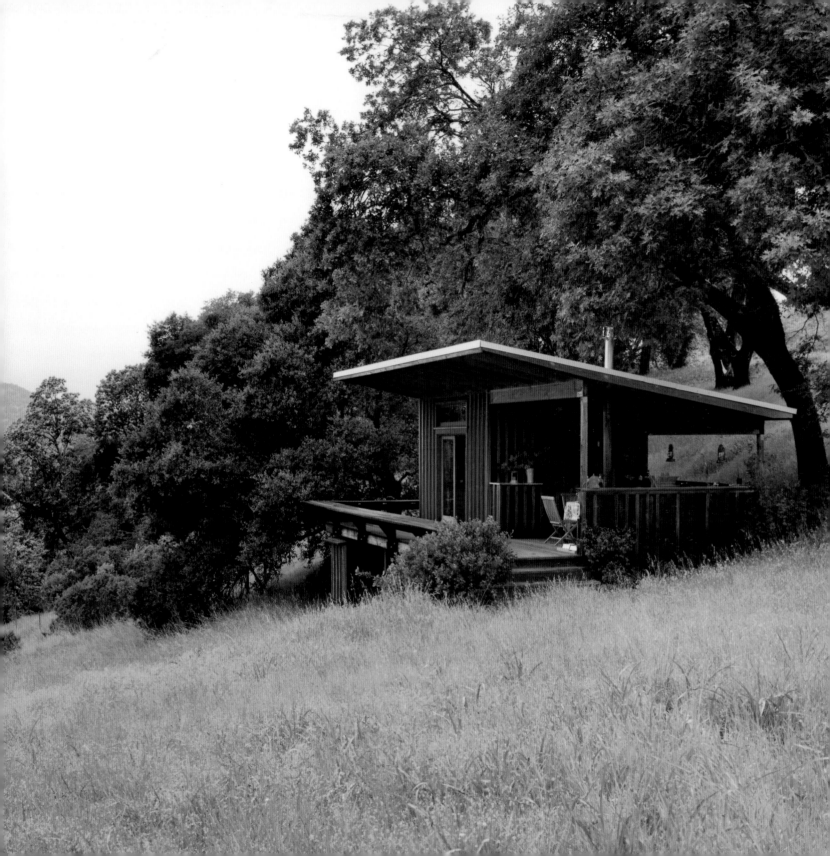

LIVING OFF THE GRID

For environmental and economic reasons, many people are choosing off-the-grid living for their weekend retreats. Living off the grid means there are "no lines in, no lines out"—that is, no connection to electric, water, sewer, or gas lines. While living off the grid can mean doing without, it can also be a relief to be truly unplugged. With few distractions, you wake up with the sun and retire early, bathe outdoors, and eat fresh, simply prepared foods. Reading and walking, rather than television, provide entertainment. And living off the grid needn't be extreme. Propane heaters provide hot water, and self-composting toilets are surprisingly efficient. In temperate climes, heat isn't necessary; otherwise, a fireplace or woodstove offers ample warmth. For more on off-grid living, see the Resources section, page 174.

The architect owners of this weekend retreat employed a sloped roof to both mimic the hillside site and help create run-off during the rainy season. The roof also provides some shelter on the wraparound deck (right) so they can watch storms roll into the valley below and still stay dry. The bedroom (opposite) has glass-and-wood French doors that provide both privacy and views.

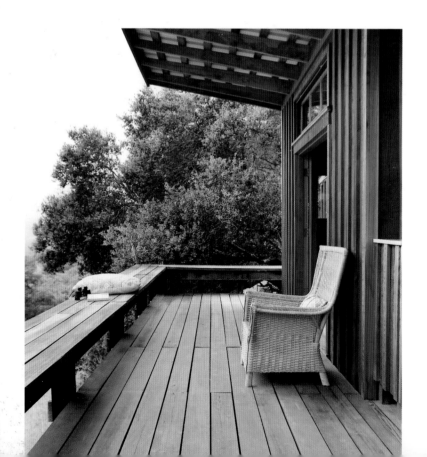

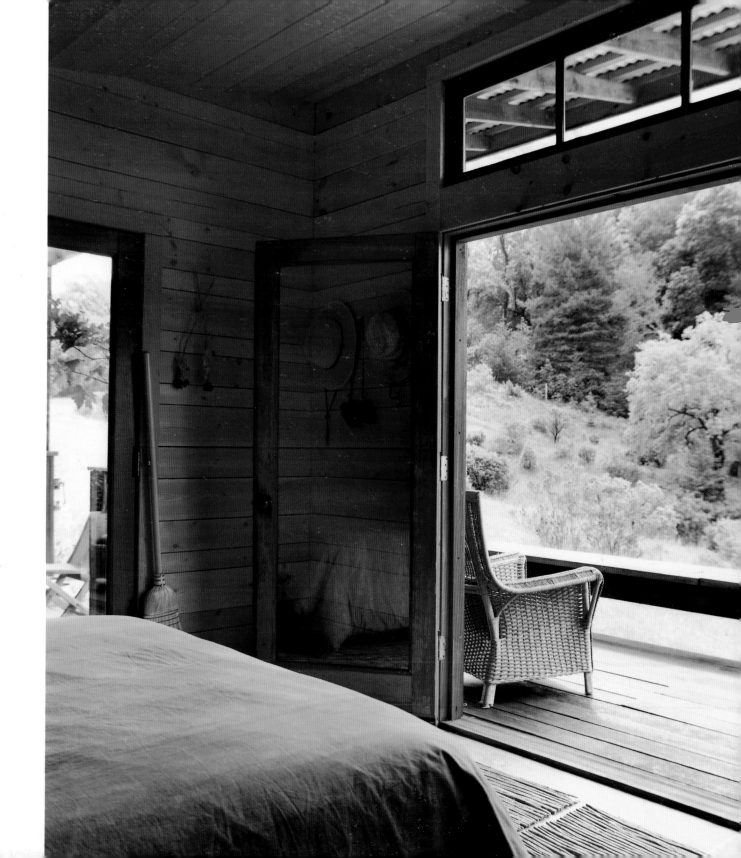

The homeowners eat (top left), shower (bottom left), and even warm themselves by the cast-iron wood stove (above) on their deck. The self-contained stainless-steel and wood kitchen (opposite) can be left open in all seasons.

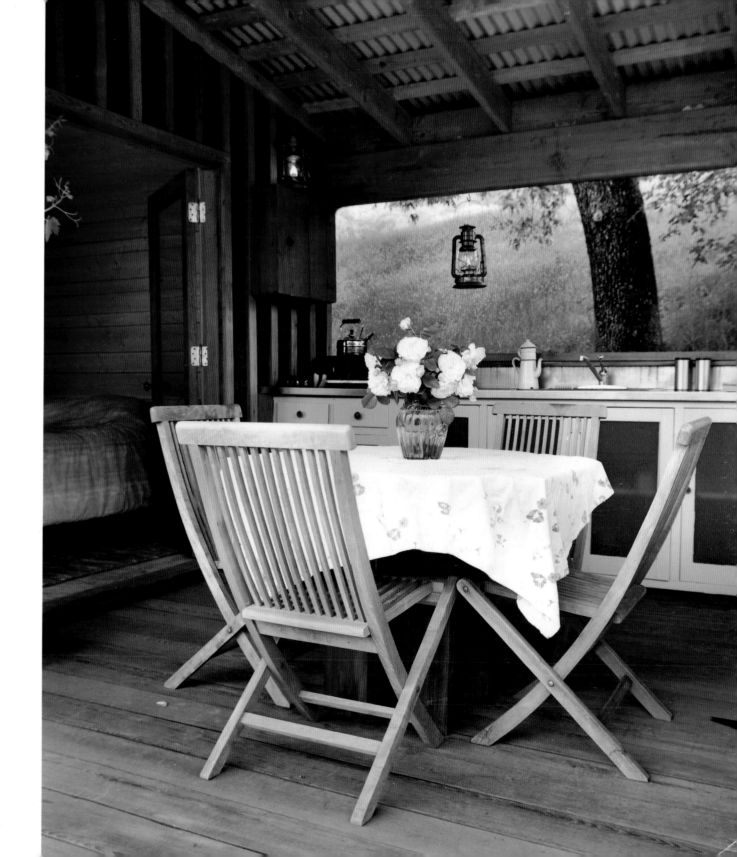

This swimming hole (left and above) offers the perfect retreat during the hot, dry summer months. A tiny dock is all that's needed to stake a claim by the water, which reflects the painterly look of the ever-shifting sky.

An outdoor living room of sorts (above left and opposite) is centered around this century-old oak tree, which gives the site a sense of history and provides much-needed shade in summer.

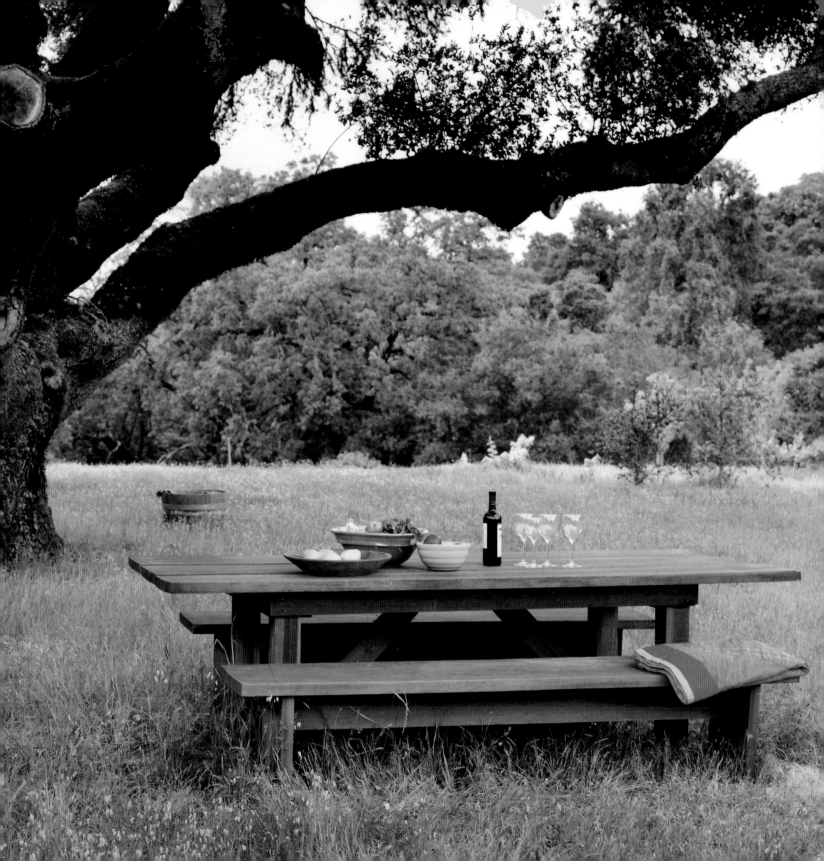

Tent Cabin Retreat

Camping suggests a peaceful commune
with nature, but when the elements turn cold and wet,
slumbering in a sleeping bag within a portable tent
can get uncomfortable. That's where tent cabins, or
tentalows, come in. Rustic yet sturdy, these attractive,
versatile structures allow you to experience the sounds,
sights, and scents of nature without sacrificing some of
the comforts of home.

In this tentalow, tucked within a quiet redwood
grove, getting away from it all means enjoying a simpler
way of life—without electricity or running water—and
really relaxing. The tent cabin is equipped with everything
needed for a true retreat; complete with windows and
a door, it breathes beautifully and lets in lots of light.

There is plenty of room for a double bed, dining area,
and cooking nook inside, and outside is a spacious deck
for sunning and reading.

Tent cabins can be outfitted as simply or as grandly
as you like. Here, a light-colored palette mixes perfectly
with the white of the tent, which reflects heat to stay cool
but lets in sun for light. A plywood floor is painted an
ochre color, and a rustic table and chairs look appealing
in white and off-white. A vintage Eames chair and small
metal cabinet for dishes are also in neutral tones.

Rustic furnishings give this tentalow a cozy,
cabinlike feel that somehow seems steeped in history
even though the tent itself is fairly new. A vintage
metal bed adorned with an antique quilt speaks of
summer retreats of long ago; handmade lanterns and a
proliferation of candles also lend a rustic atmosphere.

The space is equipped with a camp stove for simple
cooking; larger meals for friends are prepared outside
on a communal barbecue. With the simple life in mind,
time is spent napping, reading, listening to nature. Here,
beneath the canopy of redwood and fir trees, you can hear
birds flying, trees rustling, and deer ambling about. It
is just the place to retreat to when you can't bear to hear
another cell phone ring or car horn honk.

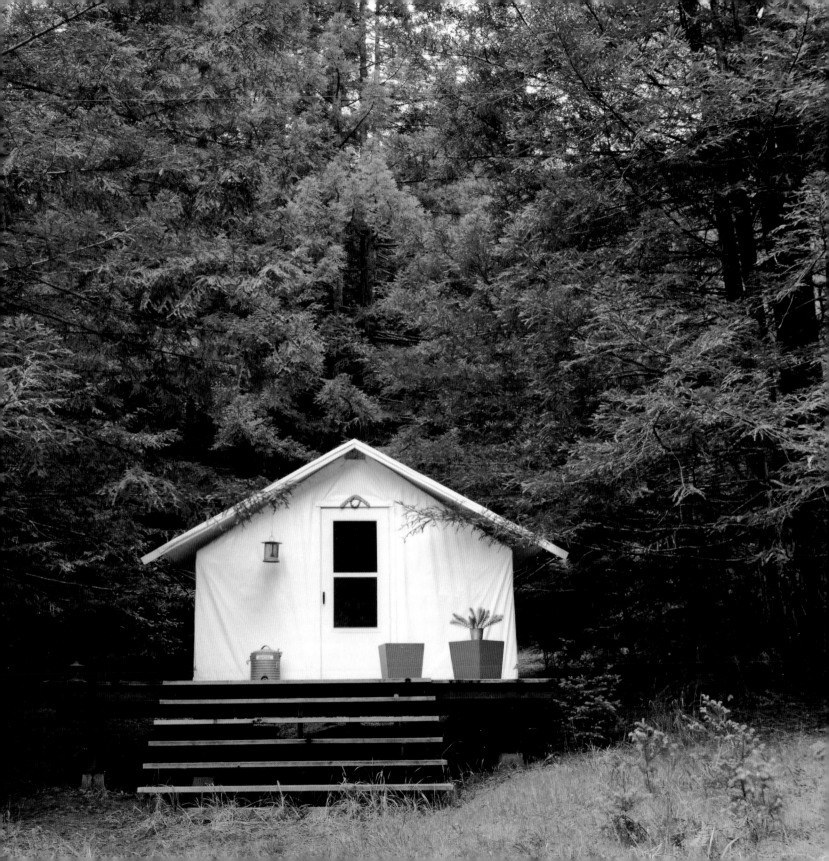

TENT CABIN BASICS

Affordable, durable, and easy to maintain, tent cabins, such as those offered by Sweetwater Bungalows, are a practical way to experience luxury camping. Mounted on stable wooden platforms and fitted with windows and screens, these prefabricated portable shelters are simple to install, disassemble, and relocate. The easy-to-clean shell is made of durable polyester vinyl; the eave-and-awning system is fashioned of galvanized steel. The framing is of spruce and steel. Tested to withstand heavy winds and rains, the tent also features an inch-thick, solid wood storm door with an adjustable window, a heavy-duty push-button handle, and an inside security lock. Options include aluminum single-pane windows and a spacious deck. Sizes vary from ten-by-twelve feet to fourteen-by-twenty feet. Cost begins at approximately three thousand dollars. For contact information, see the Resources section, page 174.

SUPPLIES TO KEEP ON HAND

A tent cabin retreat calls for only a few simple supplies:

::: LANTERNS AND CANDLES

::: GRASS MATS, RAG RUGS, OR WOVEN VINYL RUGS

::: COOLER AND CAMP STOVE

::: LIGHTWEIGHT, FOLDABLE FURNISHINGS

::: BOOKS AND GAMES

::: PROPANE HEATER

Note that in wetter climates, mold and mildew can accumulate within the tent. Keeping supplies such as linens and clothes in plastic storage containers helps diminish the problem.

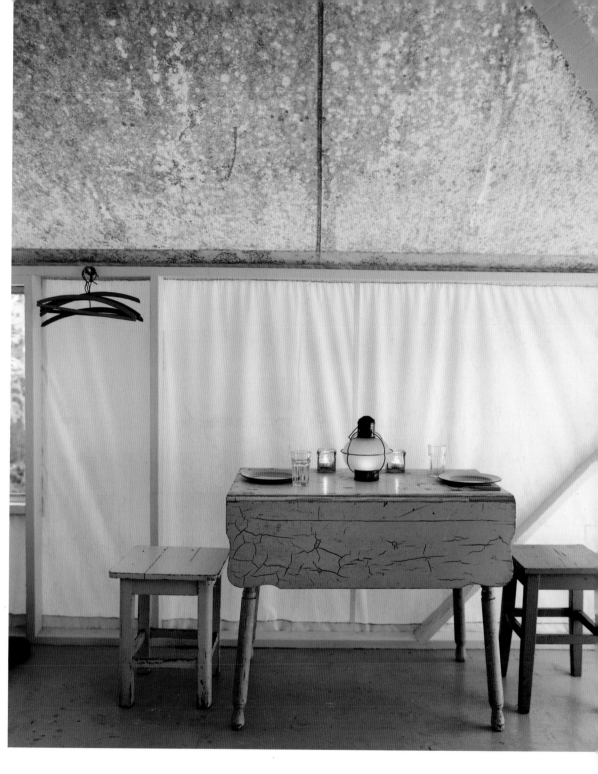

Luxury camping in a tentalow allows for rustic cooking and dining with the help of a camp stove, candlelight, and basic utensils. The structure of the tent lets light in but keeps wind and rain at bay.

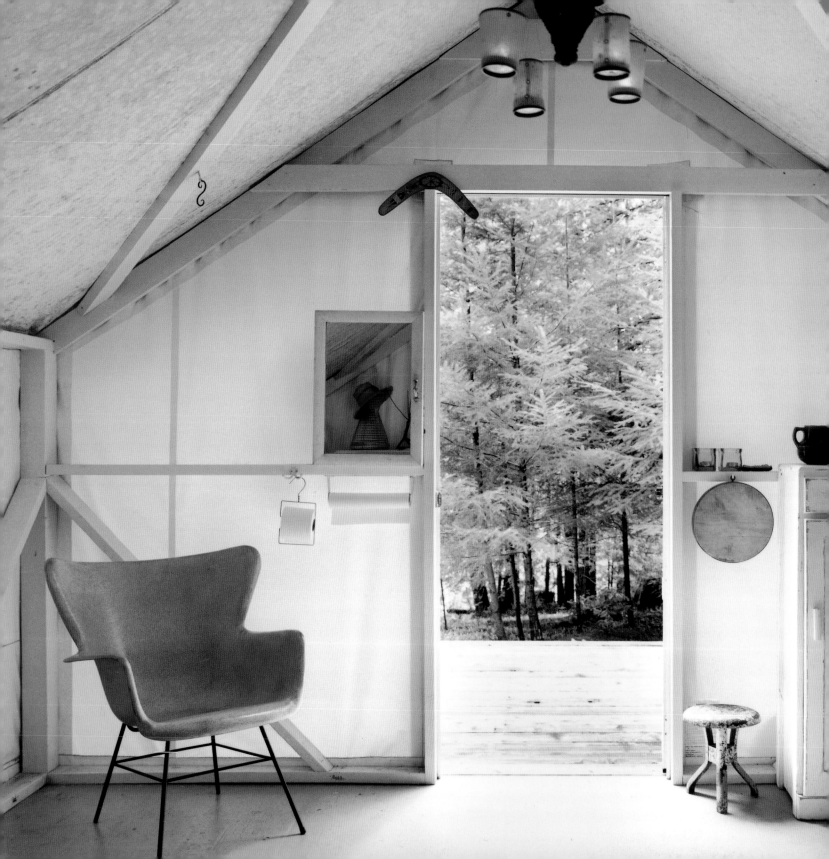

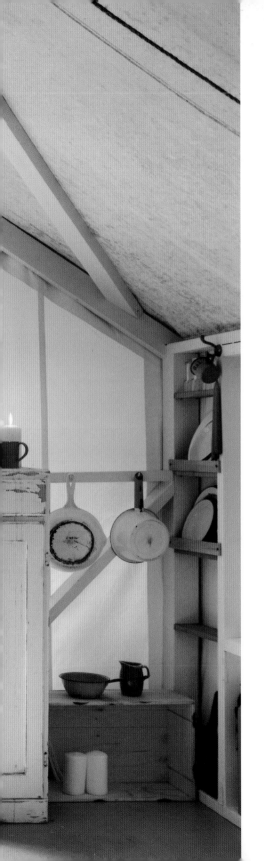

Made of durable polyster vinyl with a spruce-and-steel frame, these camp tents have screened windows and lockable doors to create a cabinlike environment. A deck outside allows for alfresco dining or lounging under a canopy of redwoods. The floor is made of plywood and furnishings are kept simple so as not to overwhelm the small, efficient space.

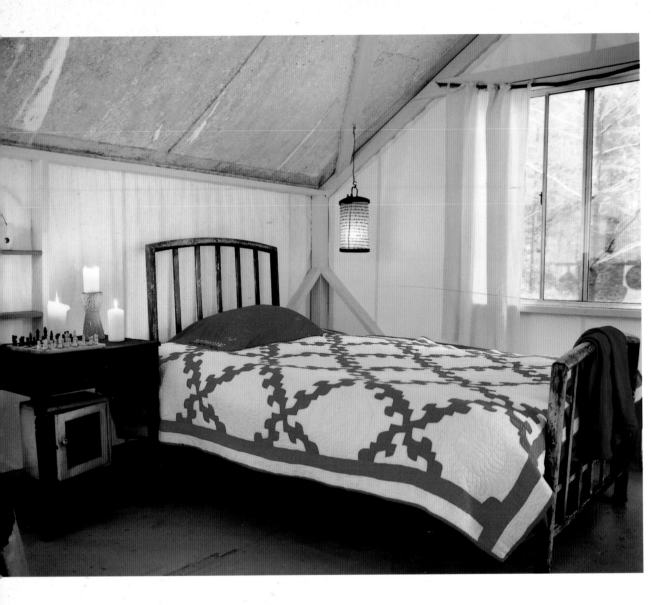

Curtains fashioned with sheer fabric and hanging from a repurposed tree branch soften the window by the bed (above), cutting down on glare and bringing a homey feel to the tent cabin. An antique metal bed and vintage quilt are other cozy touches. A dining table (opposite) is outfitted with a makeshift bamboo shade to cool the communal eating area.

Prefab Getaway

Sometimes the very best method of escape is a transparent, glass-walled structure that turns the idea of a getaway inside-out. As with this prefabricated, one-room retreat, what you see is what you get: an up-close and personal relationship with nature in a truly modernist setting. Call it mid-century meets the outdoors.

Designed as a moveable studio, guesthouse, or mini vacation retreat, this prefabricated dwelling is a clean-lined structure that can be placed almost anywhere in a mild to moderate climate. The ten-by-twelve-foot space is in essence a mini portable home and can be assembled with ordinary household tools. It is made of corrugated steel, fiberglass, and fiberboard, with an operable window. The outside is clad in a rich-toned ironwood (Ipe) to blend in with the wooded surroundings. An entire wall of glass allows for plenty of natural light, luxurious views, and a spacious, open feeling.

Inspired by the case study houses movement of the 1950s that emphasized readily available materials and streamlined designs, this modular dwelling is a relatively affordable way to have a simple yet sophisticated getaway anywhere you choose—even in your own backyard. Imagine a space all your own for yoga and meditation, gardening, writing, or working.

Here, the inside-out house nestles into a pine grove on a foggy, coastal bluff. From their bed, the owners can watch the sun rise and the fog roll in over the dense valley below. Sweeping curtains allow for shade, privacy, and coolness when desired. To create your own window on nature, all that's needed is the ideal spot on which to place this stylish, self-contained retreat.

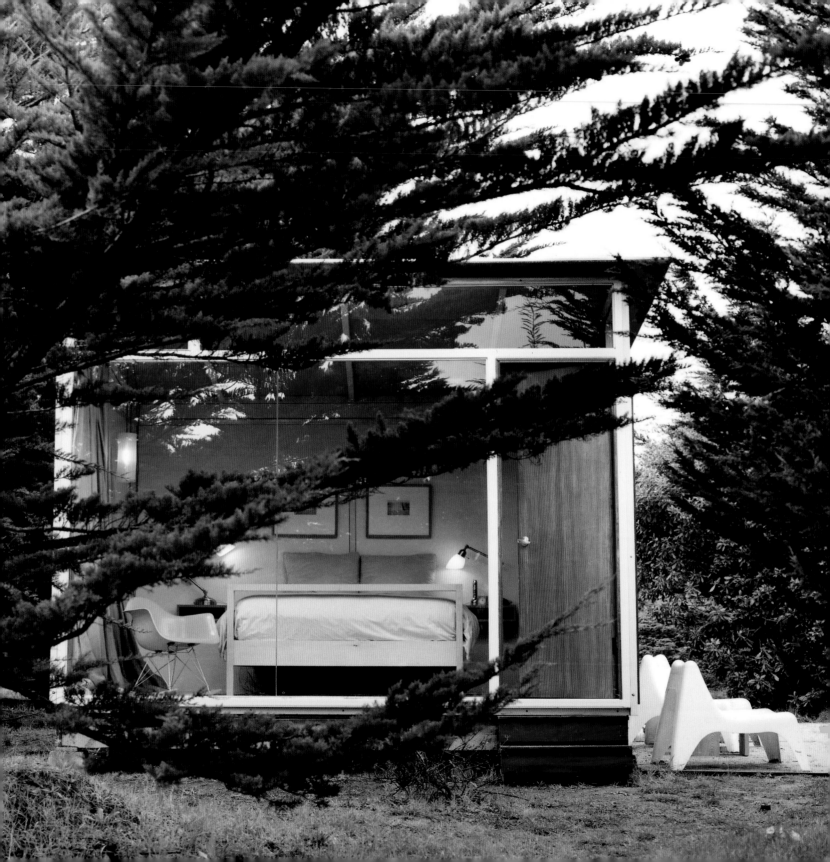

PREFAB PRIMER

In the early twentieth century, Sears Roebuck pioneered the kit house. Ever since, prefabricated houses have been widely available, but mostly in traditional designs. Now, innovative architects are providing more exciting options for modernist sensibilities. Contemporary prefab houses are available in all shapes and sizes to suit many budgets.

An ideal blend of form and function, prefabricated dwellings have hit their stride, offering flexible, affordable, modernist structures for all needs. Prefabs are designed to be inexpensive, well built, and delivered ready to assemble. This modular dwelling costs about fifteen thousand dollars and can be assembled within a couple of days. For contact information, see the Resources section, page 174.

The house's boxy (right) shape celebrates modernist tenets of streamlined design. Constructed of corrugated steel, fiberglass, and fiberboard, this one-room retreat can be assembled in a matter of days. It's the ideal getaway for weekends and can even fit in the backyard for peaceful yoga sessions or extra workspace.

This prefabricated haven measures ten-by-twelve feet for simple living. A wall of glass (opposite) brings the outdoors in so inhabitants feel surrounded by nature.

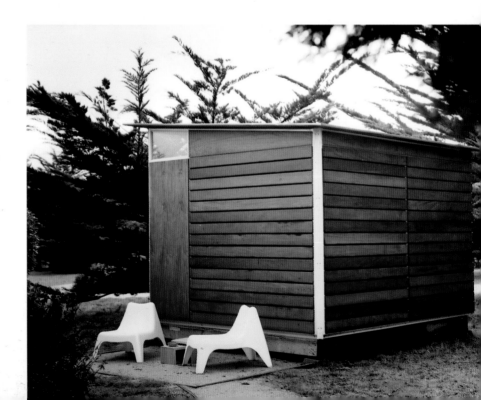

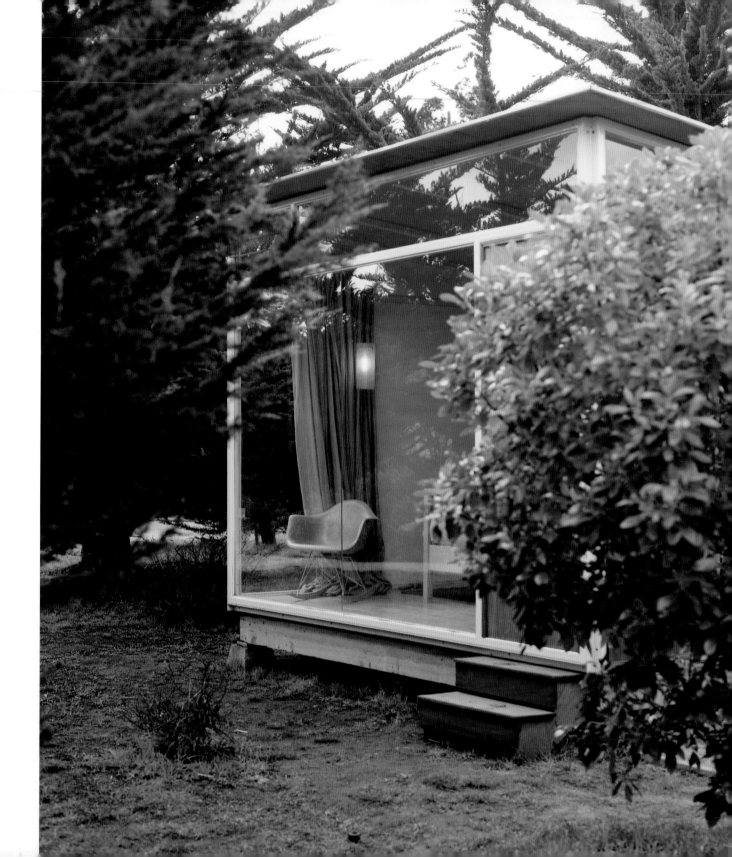

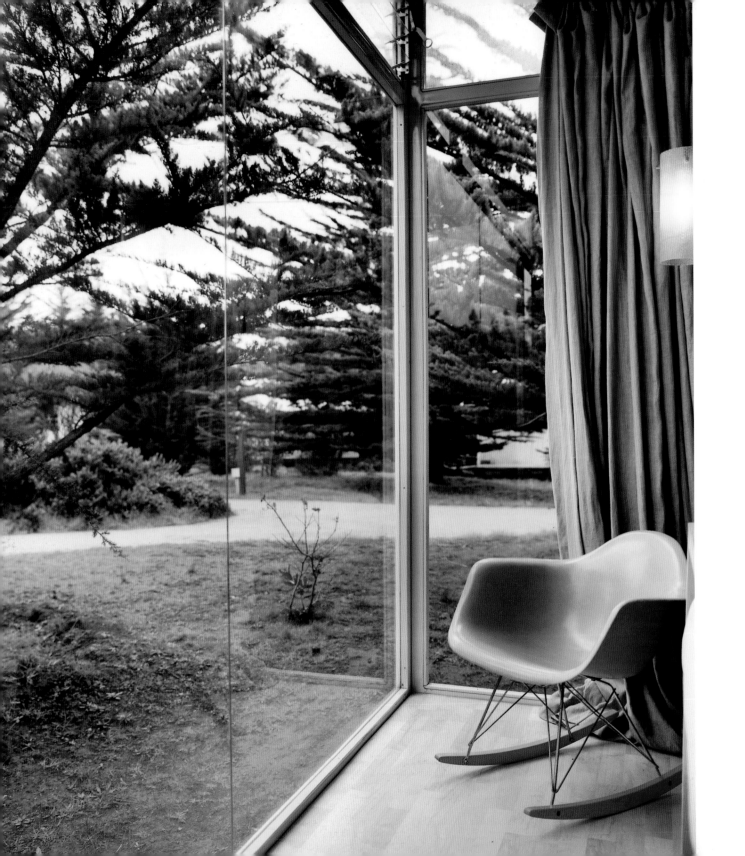

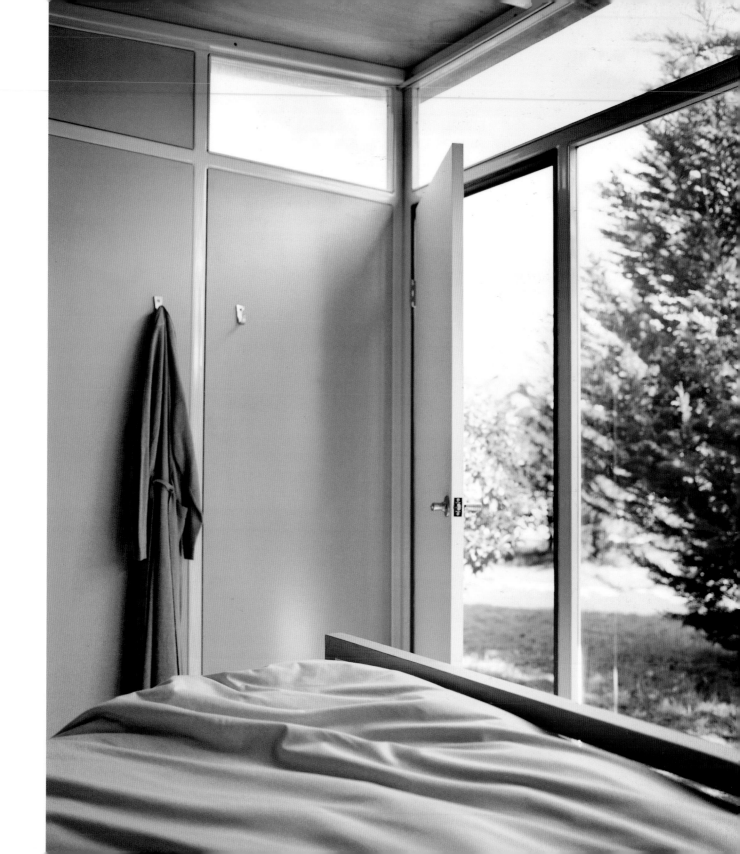

Pages 44–45: A thick wall of glass makes up the facade of this see-through retreat, giving new impact to the idea of a "window on creation." Sleeping just a few feet from nature gives one the feeling of being in a glass tent. From the bed, one can watch the fog roll in and awake to a glorious sunrise.

Painted plywood walls (left and below) echo the color of the sky. Furnishings are ultra-sparse.

Clad in ironwood, or Ipe, a sustainable material harvested in South America, this modular dwelling features rich tones that fit well into a natural setting. Horizontal slats (right and below right) emphasize the house's low-slung design, which makes minimal impact on its surroundings.

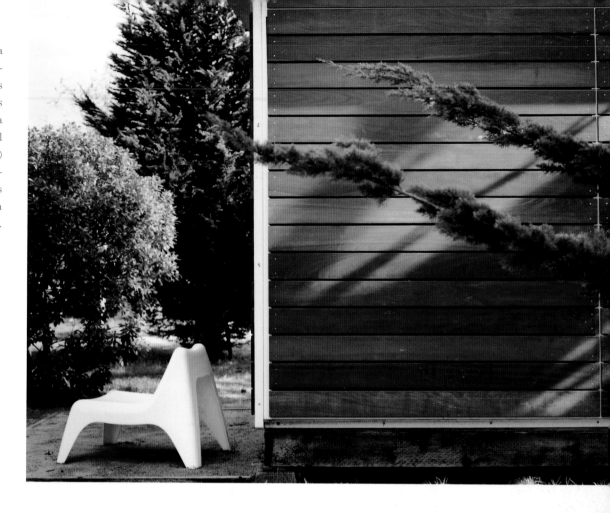

The beauty of the prefab retreat is that it can be placed almost anywhere in a temperate climate. This site embraces a foggy coastal scene (left).

Tree House

To a child, tree houses signal a magical world of fun and fantasy, a place to let the imagination run rampant. This is the domain of the Swiss Family Robinson, who built a tree-house refuge and lived happily ever after. But tree houses—and daydreams—aren't just for kids, as this arboreal aerie attests.

Nestled into two giant fir trees, this hideaway appears woodsy and rustic on the outside. Clad in redwood, which ages perfectly to integrate with its surroundings, the house sits thirty feet above the ground, with wrap-around decks for outdoor seating and gazing at the spectacular view.

Once beyond the ornate double doors that lead inside, however, an opulent dreamworld unfolds, suggesting a gilded woodland. The spacious one-room living area, with its luxurious four hundred square feet and soaring sixteen-foot ceiling , is anchored by a gilded daybed fitted out with gold silk velvet. Custom made of birds'-eye maple, it has delicate gold leafing and can open into a queen-size bed. More formal drawing room than boyhood fort, the rest of the decor takes the theme of the woods and turns it on its head, with regal results. Hanging from the ceiling are two gilded, forged steel chandeliers modeled after oak branches. Curtains of metalized cotton with gold threads pool from the oversize windows. Walls are upholstered in putty-colored cotton.

To enhance the arboreal atmosphere, the owners covered their Louis XV–style chairs with fabric in an overscale faux bois (fake wood) pattern. Chinese tree stumps make for luxuriously rustic stools. Outdoors, handmade branch chairs, picked up at a local shop, are a lovely place to perch. But luxuries are not forgotten: a low Chinese chest holds a sink and vanity, and a tall Chinese cabinet stashes a flat-screen television.

Used as guests' quarters and as a painting studio, this jewel-like retreat represents the unexpected—a sparkling gem hidden among the birds' nests and branches.

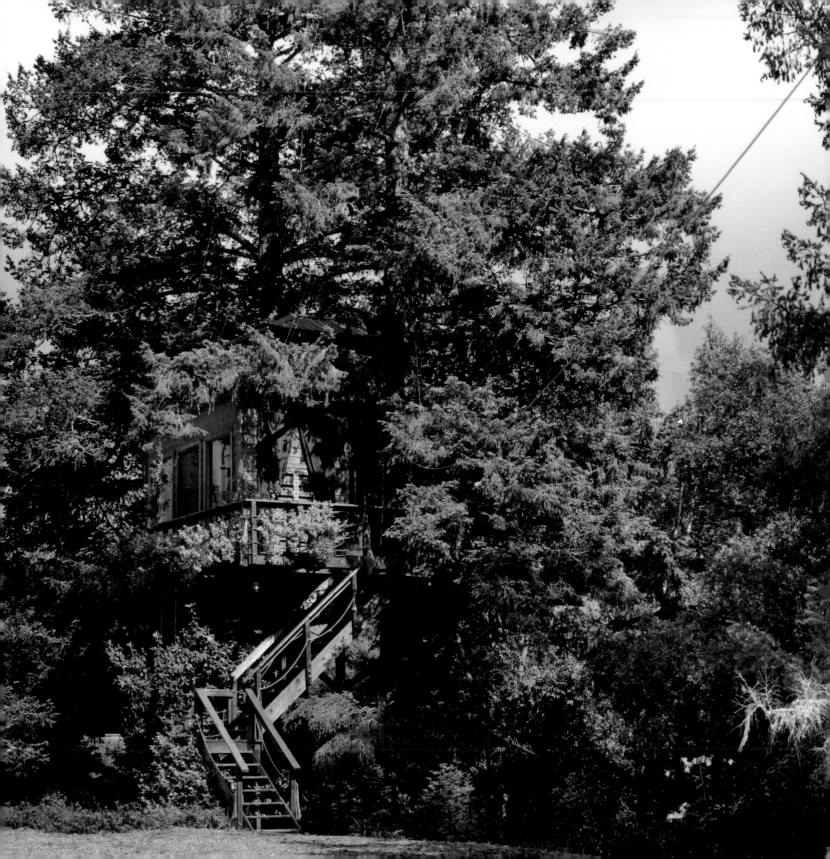

LIVING OUT ON A LIMB

The most legendary tree house of all is probably the arboreal abode built by the Swiss Family Robinson, Johann David Wyss's shipwrecked characters who rowed to an island and used driftwood and palm trees to build a three-story refuge to protect themselves against wild animals.

Historically, tree houses have been common among indigenous peoples in the South Pacific and Southeast Asia, who built thatched nests and transported themselves up and down in large baskets. The shelters provided safety from mosquitoes, animals, and enemies.

Tree houses are famous in the Western world as well. Roman emperor Caligula held lavish banquets in the branches of an enormous plane tree. During the Italian Renaissance, the Medicis vied to see who could build the grandest tree house; Cosimo furnished his tree house at the Villa Castello with plumbing and a marble table.

In modern times, tree houses have been gaining in popularity, as attested by the wealth of literature and Web sites on the subject. You can buy plans for your own tree house to create the ultimate backyard or weekend retreat. Or, simply visit one of the many tree-house-based resorts or guesthouses that have appeared in recent years to see how you like living out on a limb. For more information, see the Resources section, page 174.

Perched thirty feet above the ground, this arboreal retreat offers a luxurious, fanciful take on the traditional tree house. Carved wood doors with inlaid stained glass (right) signal entrance into this regal retreat. The wood-themed decor continues outside with garden chairs fashioned from branches (opposite).

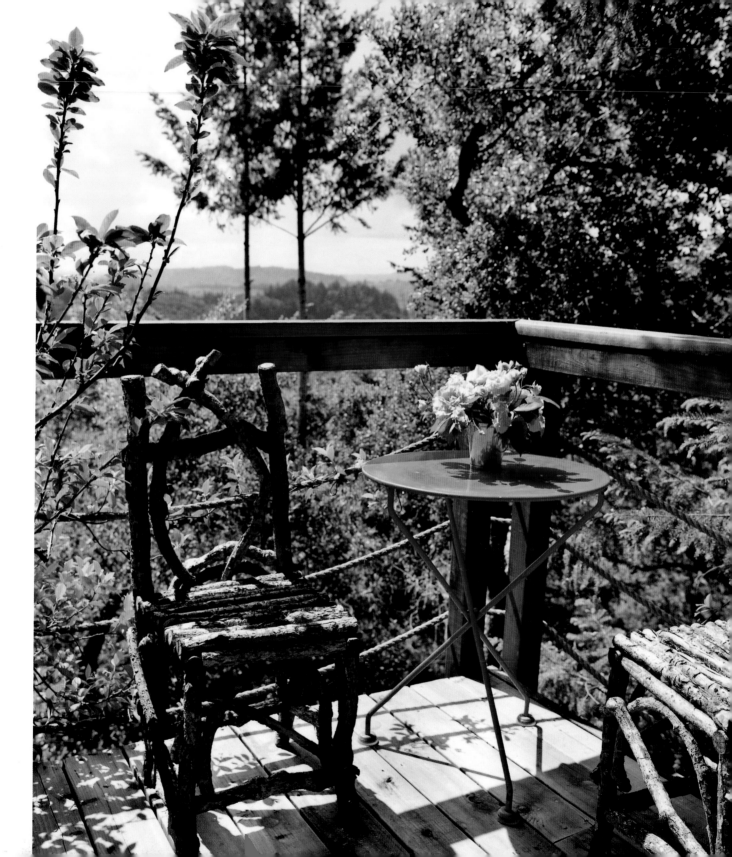

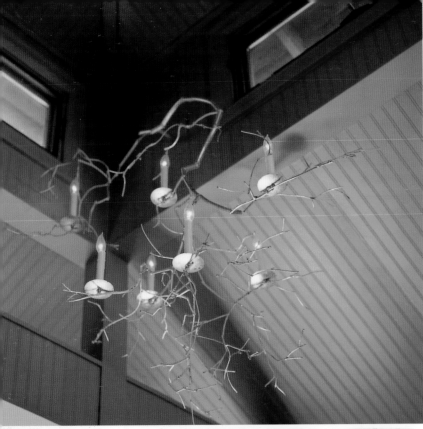

Soaring, sixteen-foot ceilings feature clerestory windows to bring in more light. The handcrafted chandelier is made of gilded forged steel and modeled on oak branches (left). A Louis XV–style chair (below) is adorned with faux bois on fabric, a painting technique used to mimic wood. A wraparound deck (opposite) affords spectacular views of the landscape.

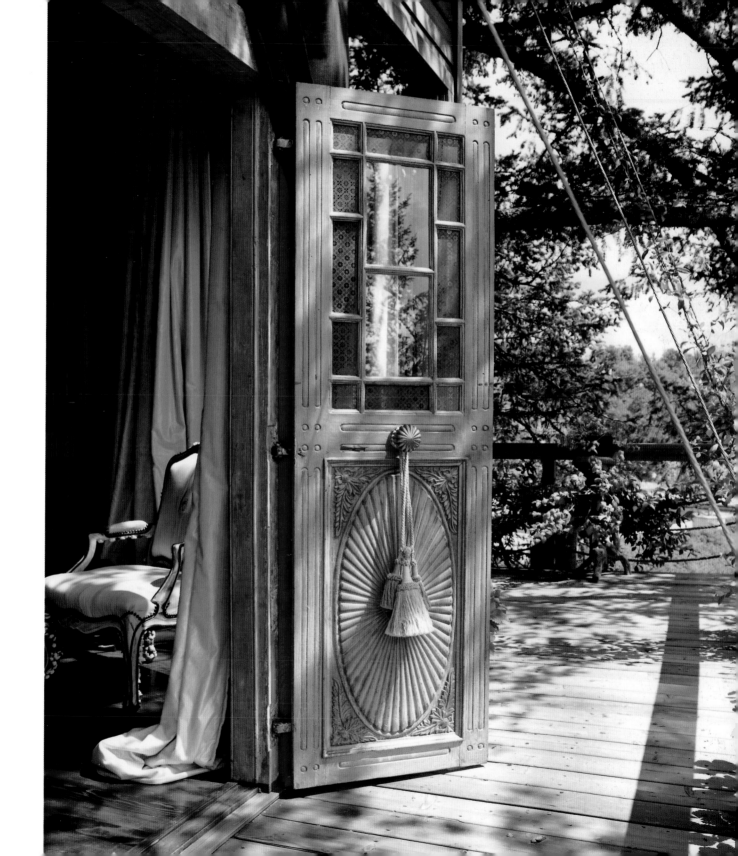

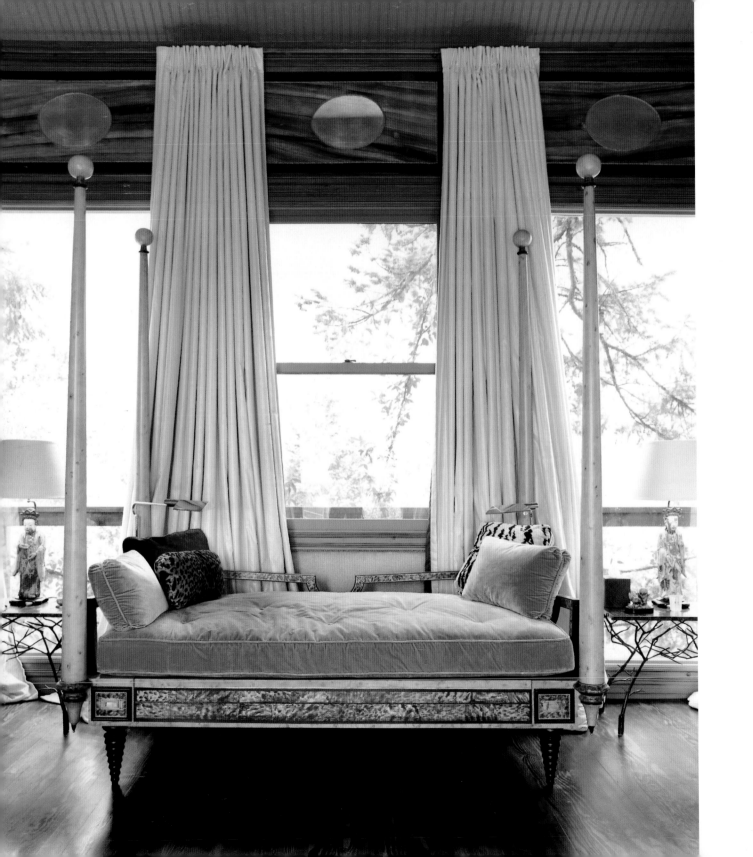

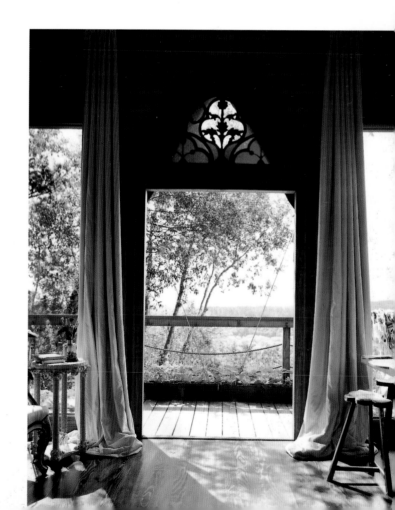

The centerpiece of this getaway is a gilded daybed (opposite) fitted
with gold velvet silk. It is custom made of birds'-eye maple, has deli-
cate gold leafing, and can open to a queen-size bed. A dining table
made of gold-leafed wood and surrounded by simple stools (above)
sets a tone of woodland luxury in this arboreal retreat. The high
ceilings are emphasized by floor-to-ceiling curtains (right) that pool
luxuriously at the bottom.

By Design in the Desert

The Wild West, the last frontier. The desert is what you make of it, a blank canvas on which to create your own life. This is a geographic locale, but also a state of mind, a chance for self-invention.

For this artist's retreat in an undeveloped region of the high desert, economy of means, adaptability, and self-expression all came into play. Because the house is only seven hundred square feet, expanding the living space outdoors was crucial. The generous patio was created with poured concrete and framing devices for definition, shade, and views.

To shelter the outdoor space from the harshness of the elements, the owner employed a horse shelter made of galvanized steel and corrugated metal. Durable redwood furnishings outfit an eating and lounging area. To create a barrier against coyotes and other animals,

there is a wall of cinderblocks at one end of the patio, with a carved-out glass window to bring in a view of the neighboring flora and dramatic rock formation. An aluminum watering trough has been pressed into service as a bathing tub; during hot weather it also is used as a cool plunge pool.

A desert palette is reflected throughout the house. In the bedroom, warm reds and oranges are reminiscent of sunsets; in the bathroom, earth tones make for a calming space that beautifully echoes the outdoors. Glass tiles in brown around the sink are offset by a simple wooden medicine cabinet.

The kitchen was handcrafted to be both efficient and evocative of the landscape. A system of countertops, cabinets, and a banquette has been fashioned out of birch plywood. The lightness of the wood helps brighten the indoors and reflect sunlight. Cabinets are painted sage green in homage to the native plants outside. Birch ply is also used on the ceiling and walls.

Throughout the house, colors, textures, and forms were chosen to mimic the outdoors, an affirmation of the powerful desert landscape.

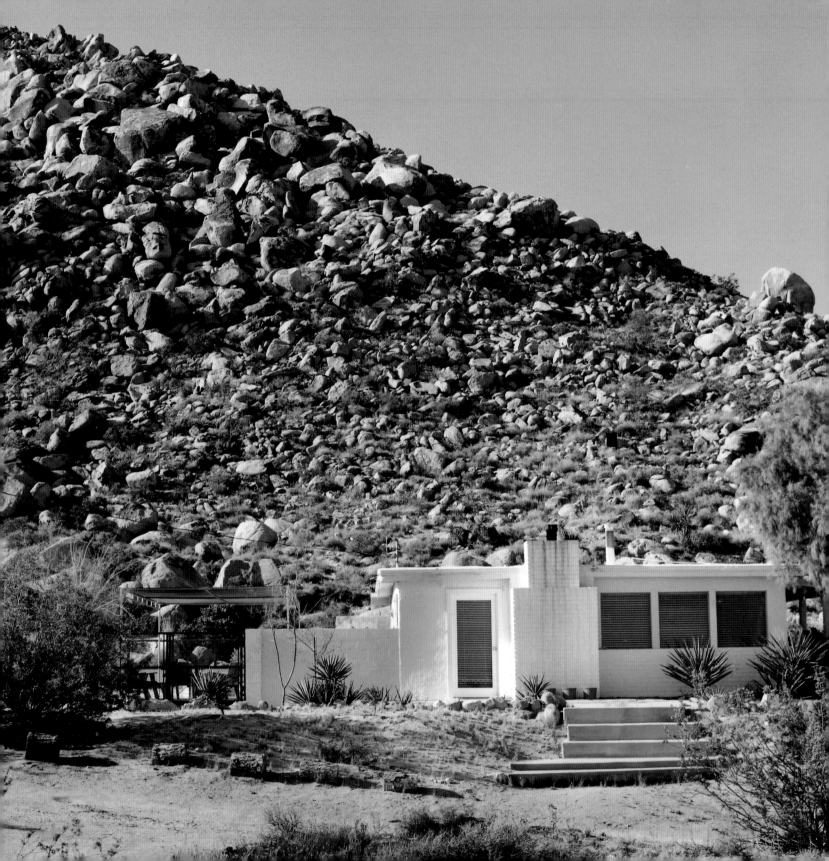

DESIGN DETAIL: REINVENTING THE HORSE TROUGH

Often used as inexpensive planters in city gardens, horse troughs also make great outdoor tubs. In 1883, John Michael Kohler of the Kohler Bath and Kitchen Company took a trough and encased it with enamel. He included it in the company catalog, explaining, "A horse trough/hog scalder when furnished with four legs will serve as a bathtub." The first Kohler bathtub was traded to a local farmer for a cow and twenty-four chickens. Such troughs soon gave way to more stylized bathtubs with rolled rims and brass fittings. These days, many do-it-yourselfers prefer the simpler aluminum version.

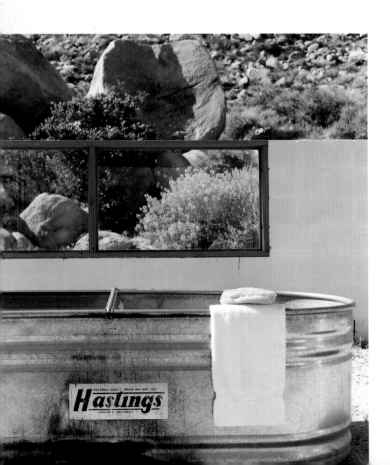

The desert landscape goes a long way toward informing the palette and decor in this artist's retreat. At once harsh and beautiful, the surroundings are marked by rocky outcroppings and eye-catching brush. An outdoor bathing area (opposite) is made of up of an aluminum horse trough.

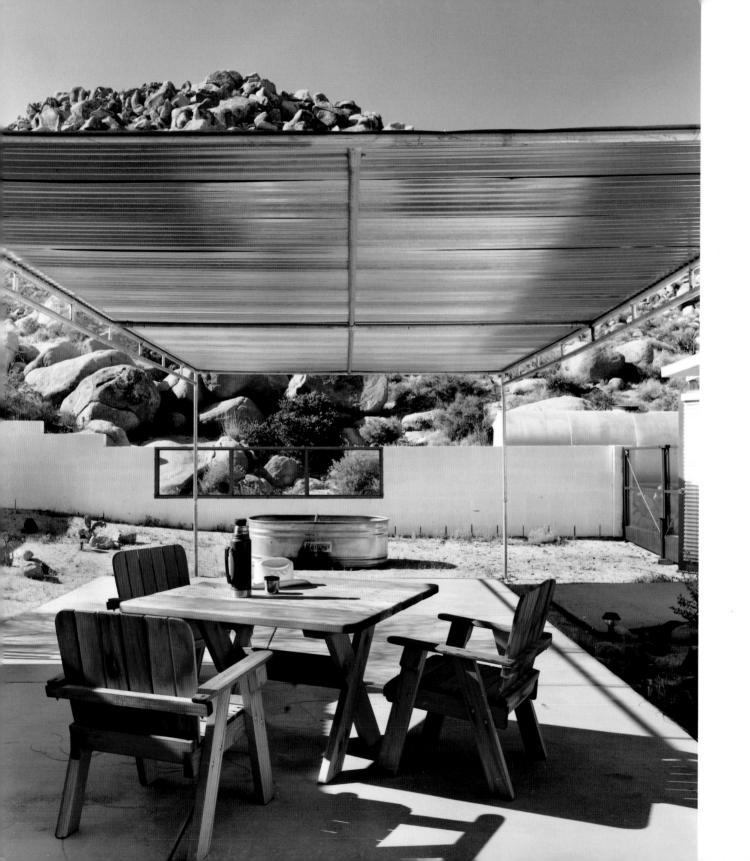

Protection against the elements is a must in the desert, where heat and winds can be severe. A shaded outdoor patio (opposite) is created with the help of a galvanized steel and corrugated metal horse shelter. A wall of cinderblocks is a barrier against wild animals; a window in the wall draws attention to the dramatic rock formation beyond.

The house's clean geometric lines offer contrast to the rough landscape beyond (below).

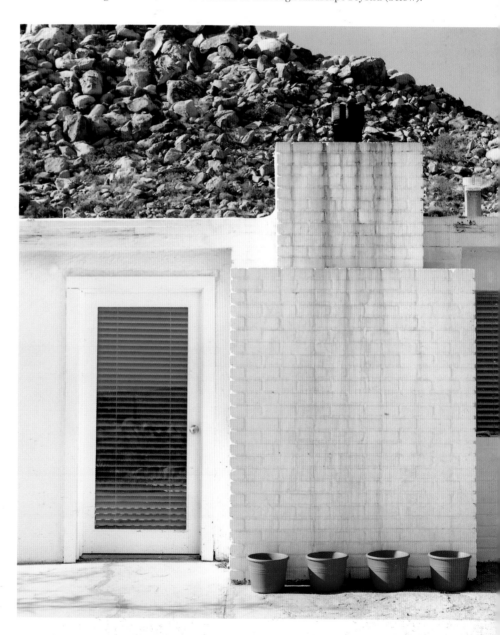

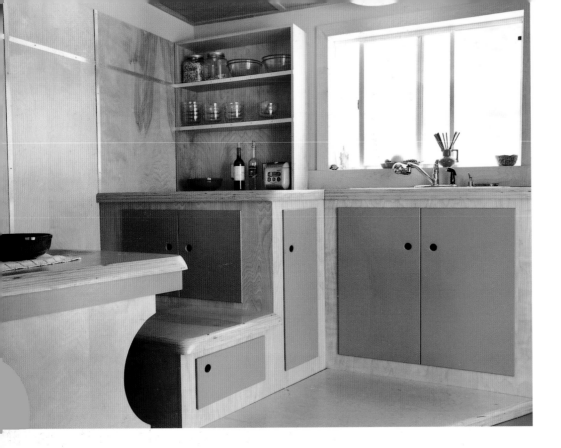

Earth tones are used throughout the house to work with the natural elements outdoors. In the kitchen (above), a system of countertops, cabinets, and a banquette is fashioned out of birch plywood, an economically practical material that also reflects light well. Sage green on the cabinets suggests the hues of the low-scrub desert landscape. Birch paneling (above right, and right) is used in several rooms to reflect light coming in through the windows.

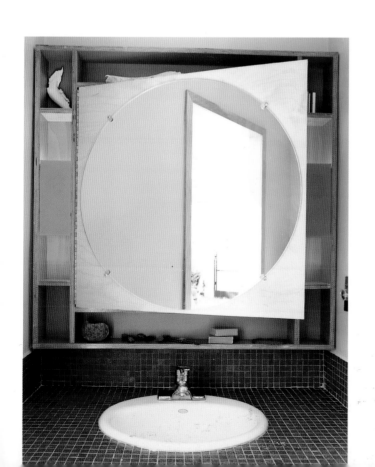

In the bedroom (above) deeper colors of gold, pink, and red echo warm desert sunsets. A grid of birch plywood on the ceilings helps bring warmth and texture into the room. In the bathroom (left) the vanity area is fashioned from stone tile and wood in soft tones of brown and green.

On the Boardwalk

If the word *boardwalk* brings to mind honky-tonk arcades, cotton candy, and roller coasters, think again. Situated on four hundred acres of marshland with spectacular mountain views, this boardwalk is the unusual setting for an unusual house. The quirky home is set on stilts and cobbled together from old barges and houseboat salvage, a summer retreat that feels as homey as it does improbable.

The house is built to modest proportions but boasts luxurious views: a 180-degree vista of verdant, unspoiled marshland to the front, and stunning water views out back. Here, you can watch morning and evening fog roll in over the mountains; days are capped by spectacular sunsets.

Constructed in the 1920s, the retreat has the compact, cabinlike feel of a houseboat; the flooring is of redwood, with knotty pine paneling in the main bedroom and in the hallways. Bay breezes waft in, cooling the house and beckoning visitors toward the water, where small boats ply the bay. Life unfolds on the spectacular sunny deck, which leads to a little dock and motorboat. Weathered teak furnishings and lush plantings of jasmine, roses, wisteria, and poppies make for an ideal spot to relax, soak in the tub, or plan an afternoon fishing trip.

Wildlife on the marsh is abundant: egrets, blue herons, night herons, Canada geese, and many varieties of duck make the marshland their home; seals breed in the far distant corner of the bog.

The mile-long boardwalk features a cluster of funky houses set close together facing the marsh. All the homeowners know one another and enjoy an easy neighborhood setting; most have bicycles to take them to the main road, where their cars are parked. Even in inclement weather, this is a lovely spot to settle in to—winter storms are intense and dramatic, particularly at the solstice tides. Inside, friends gather to cook and take meals together, watching the rains unleash from the expansive sky.

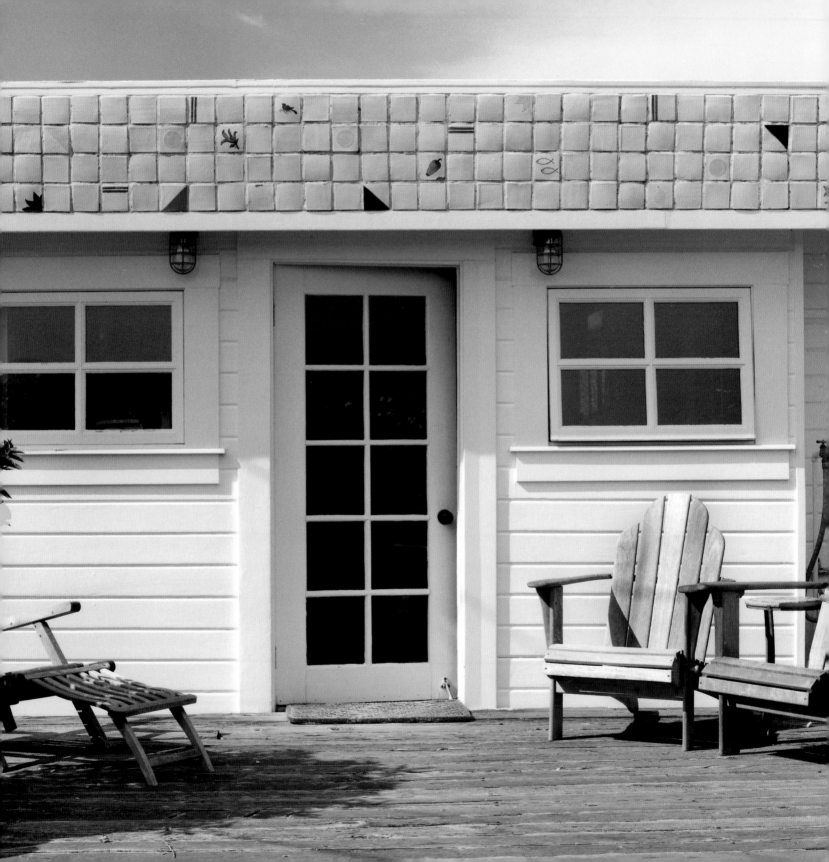

BIRD WATCHING

Birding is the fastest-growing outdoor activity in the United States; according to a survey by the U.S. Fish and Wildlife Service, 51.3 percent of Americans report that they watch birds. And more are taking it up all the time.

The ancient Romans believed that the flights and calls of birds could foretell the future; today, changes in bird populations can reflect the health of the environment.

Birding for pleasure is a great way to get outdoors, get the body moving, and connect with the beauty and power of nature. Bird watching requires little investment. You can watch birds in your own backyard, in a park, or anywhere you travel. All you need are a pair of binoculars, a field guide with pictures that illustrate which details of each bird to look for, a notebook for recording what you see, and a sun hat.

A large outdoor living space makes this boardwalk (right) retreat an ideal summer idyll.

(opposite) A picnic table of aged redwood sets the tone for casual meals and gatherings, while a vintage claw-foot tub surrounded by poppies and wisteria is a soothing spot for a cooling bath.

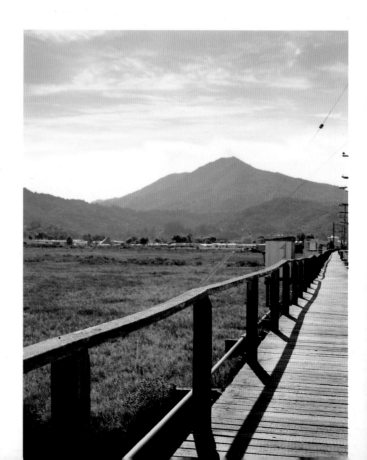

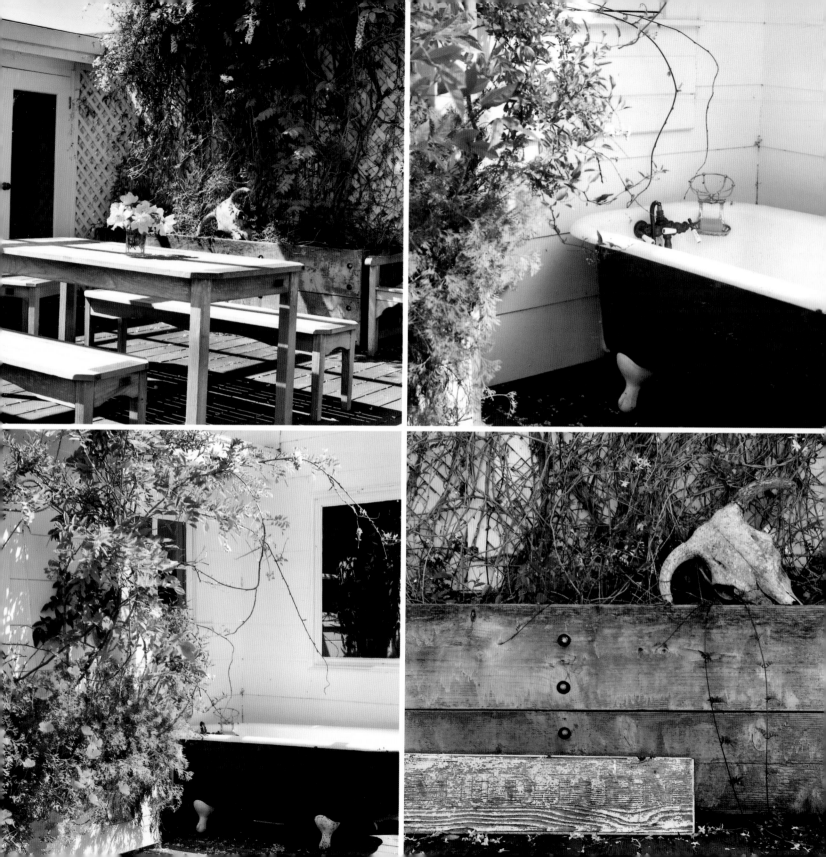

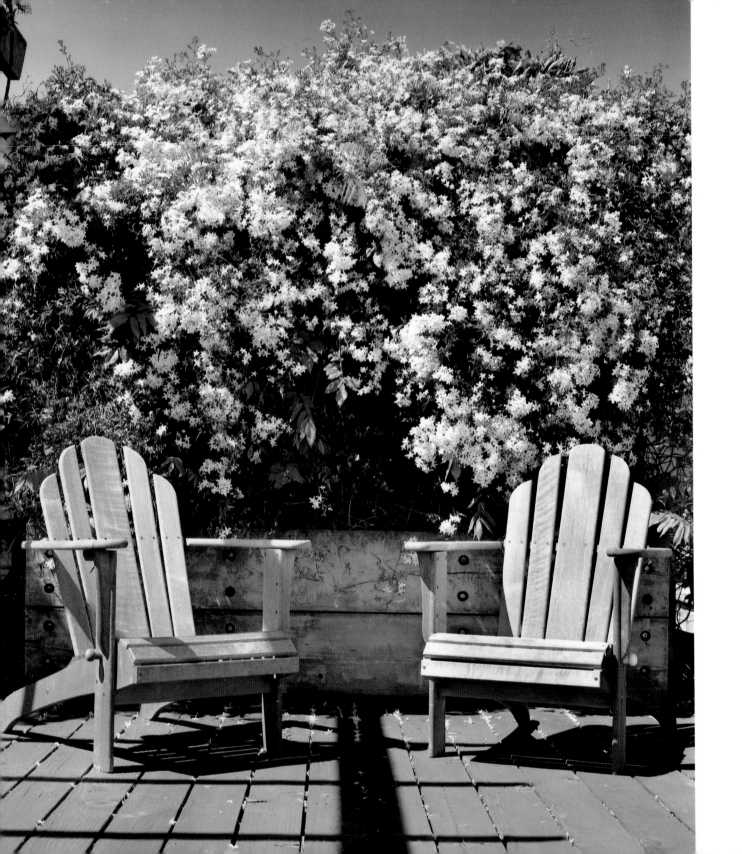

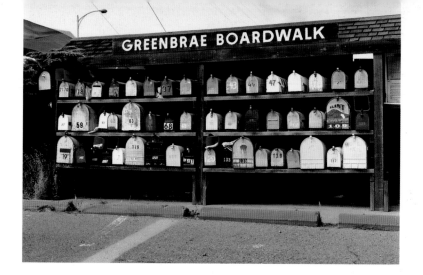

Mailboxes (above) are clustered at the end of the boardwalk of this quirky, close-knit community. The house looks onto 400 acres of protected marshland (right) with majestic mountains beyond, the ideal spot to watch sunsets and storms rolling in. Masses of jasmine (opposite) perfume the back deck.

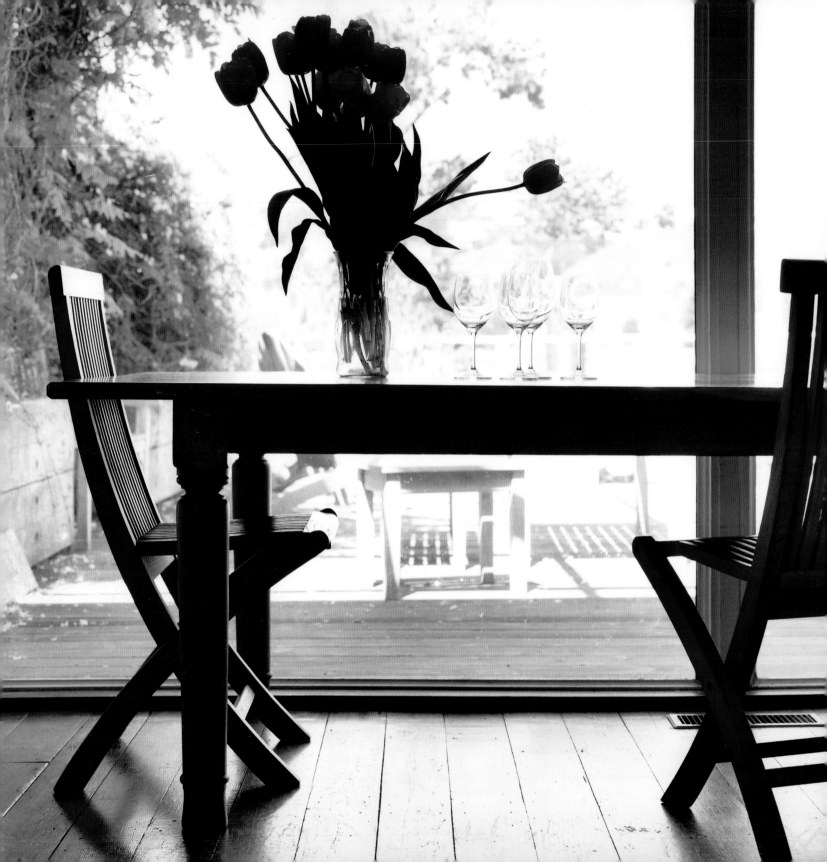

Crafted of old houseboats and salvaged barges, this retreat has an idiosyncratic, cobbled-together feel. The dining room (opposite) looks straight out onto the water; the kitchen (below) is an intimate, funky space with a cutout in the wall that peeks into the guestroom.

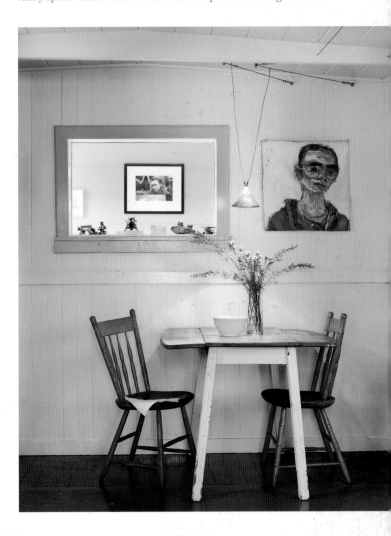

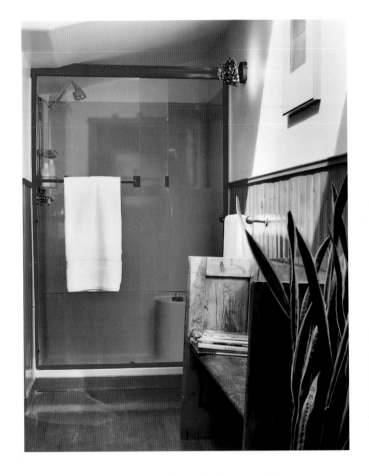

Knotty pine paneling in the hallways, bathroom, and bedroom give this retreat a cabinlike feel. Furnishings are kept spare; distinctive-looking houseplants and stunning black-and-white photography personalize the space.

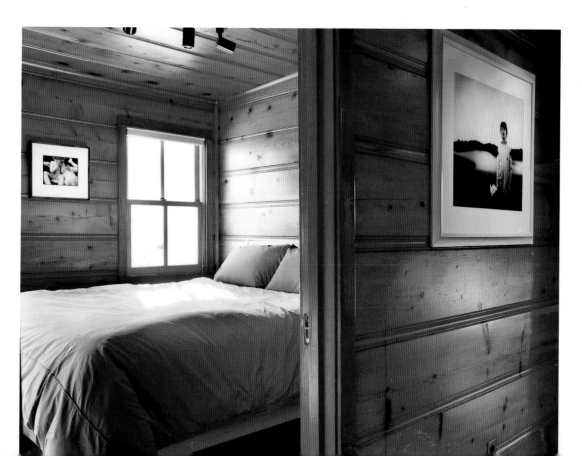

Creekside Haven

There is something deliciously private about a house on a creek. Backed by wilderness and the soothing sound of rushing water, this cabin tucked into a shady garden has all the attributes of a secluded escape.

Set on just under an acre, the house's narrow site has a lush, private feel imparted by a mature garden filled with fragrant flowering shrubs and perennials. The house abuts a rocky ravine, which provides a cooling respite in summer and an icy panorama in winter. To join the house with the outdoors, the owner built a screened porch of knotty pine with bench seating overlooking the creek and shaded by leafy trees. A bluestone patio off the porch takes in the majesty of the garden.

Throughout the property, seating areas have been carved out where privacy and views are optimal. Vintage garden furnishings lend a charming, lived-in feel; stone pathways meander through the thick, fragrant plantings. A private deck overlooking the creek is a majestic spot to sunbathe; when temperatures climb, the water offers cooling relief.

With its soaring windows and an open staircase, this retreat is made intimate by its arts and crafts design and appointments favoring warm wood, organic forms, and leather. In the living room are a slate-topped table and leather stools, examples of Frank Lloyd Wright's production furnishings. The table complements a 1950 Dunbar sofa and the owner's collection of American studio and Scandinavian ceramics. A Scandinavian-style wood-burning stove and an Alvar Aalto lamp add warmth and style.

The dining room is an arts and crafts tour de force. A local cabinetmaker created cupboards of blond and ebony wood; arts and crafts chairs, also of ebonized wood and originally designed for a lake house in Minnesota, complement a sturdy mahogany trestle table.

At dusk, the house takes on a warm glow. In the dining room, a lantern hung from the ceiling illuminates the handsome wood furnishings, throwing geometric patterns on the burnished wood floor and setting the cream-colored walls aglow.

THE ARTS AND CRAFTS STORY

The arts and crafts movement was a celebration of individual craftsmanship and design, developed as a reaction against the industrial revolution in Europe. From about 1890 to 1920, the movement was embraced in the United States by architects such as Frank Lloyd Wright and Greene and Greene and designers such as Gustav Stickley, resulting in a plethora of Craftsman-style bungalows and beautifully handmade furnishings. The movement emphasized natural materials such as wood, stone, and tile, as well as built-in furnishings such as cupboards and benches. Arts-and-crafts-style houses are easily recognized by their low-pitched roofs with wide overhangs and exposed rafters. For more information, see the Resources section, page 174.

The lush shade garden is graced with vintage furnishings (opposite) and lively artwork. Decorative elements salvaged from the facade of Alexander's Department Store in New York City make for a colorful pop art display (above).

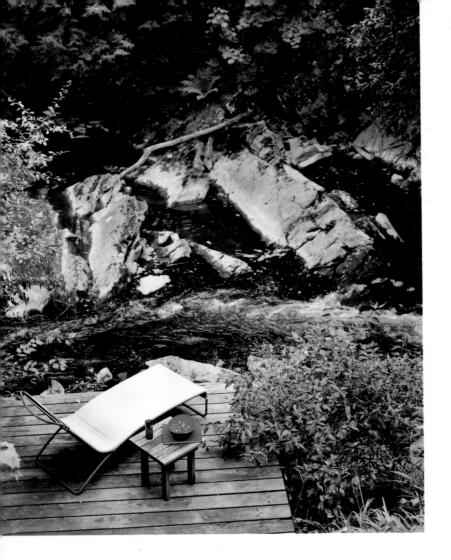

The house's landscaped grounds include pretty stone pathways (above right) and lots of niches for quiet contemplation. The retreat directly abuts a creek (above left) where private sun-bathing is a must. The living room (opposite) is a repository for American and Scandinavian mid-century furnishings, including a round slate table and matching leather stools designed by Frank Lloyd Wright.

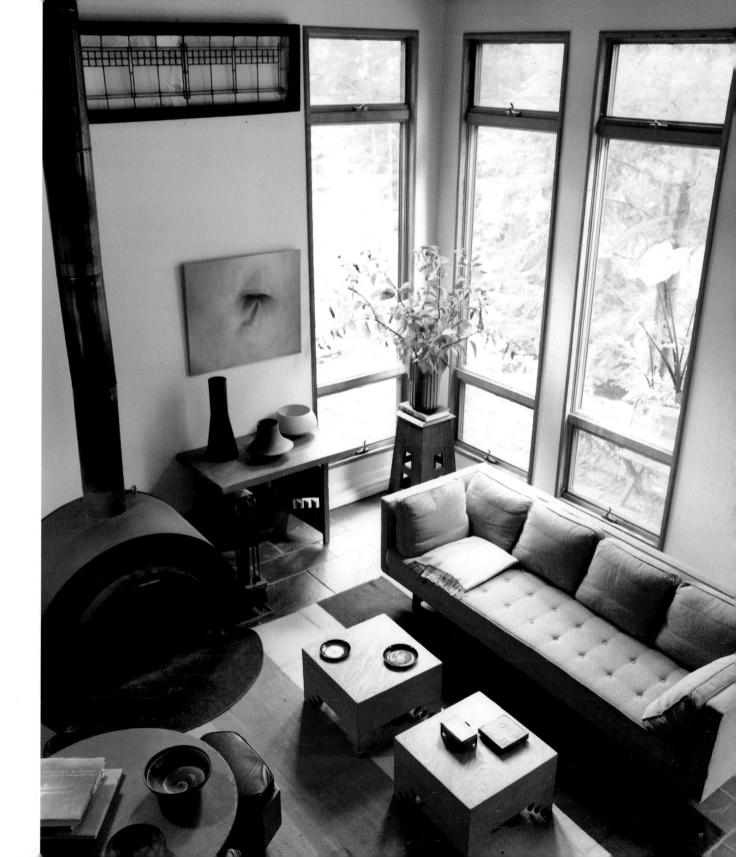

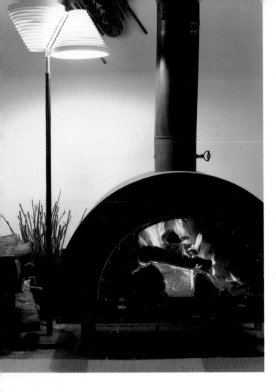

The Scandinavian wood-burning stove (left) adds warmth and style, while tall windows in the living room (below) are part of the overall arts and crafts aesthetic. A photograph by Lynn Davis hangs over a mid-century sofa. An open staircase (opposite) joins the two stories together; slate flooring grounds the room.

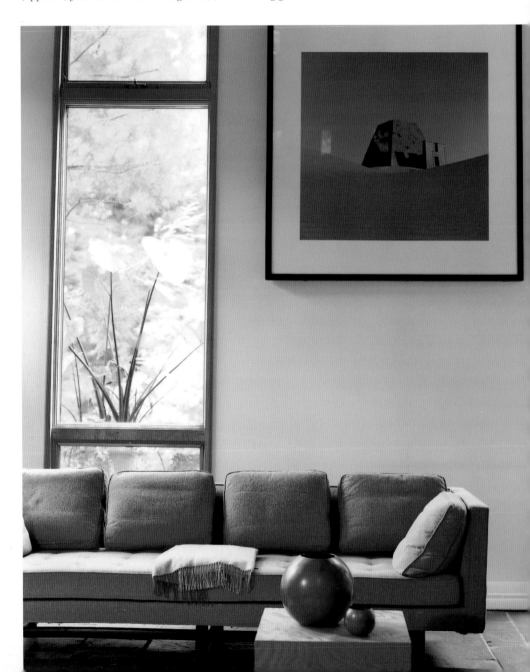

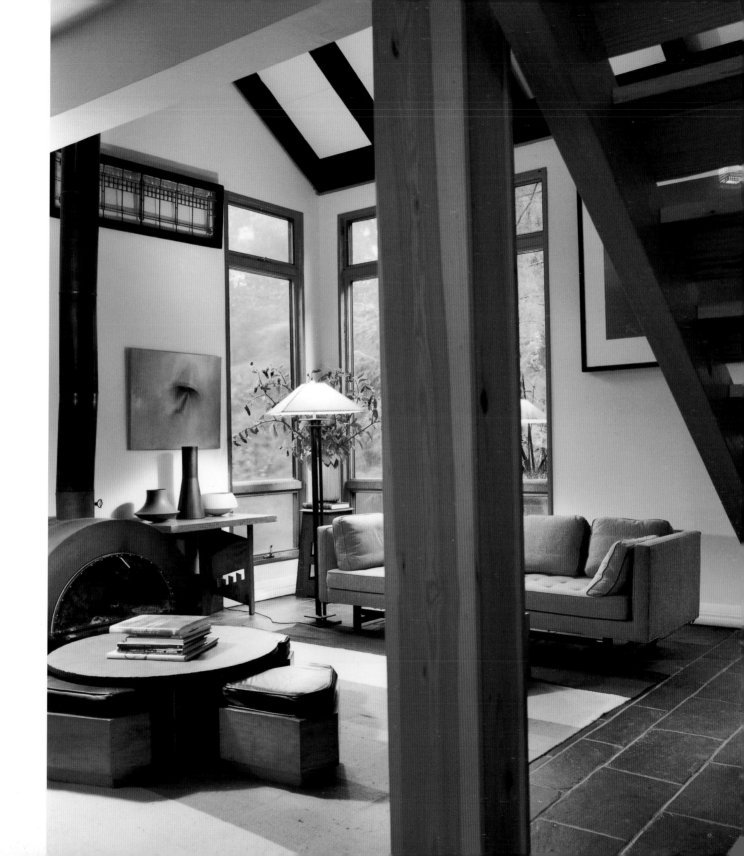

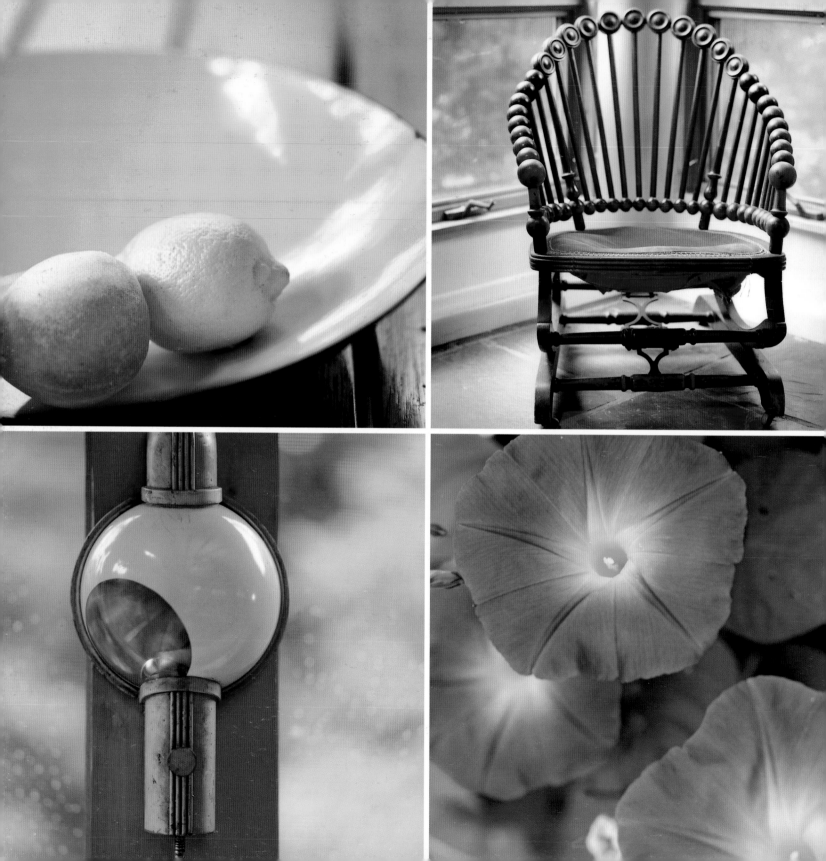

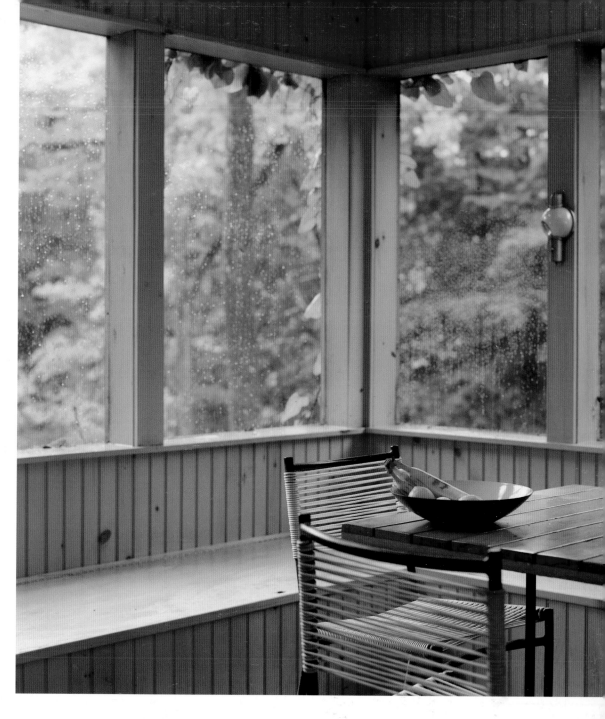

A screened-in porch (above) offers proximity to and views of the lush garden. Built-in seating made of pine lends a cottage feel to the indoor-outdoor room. A still life of lemons reflects incoming light; a Victorian Lollipop chair graces the bedroom; a colorful flower blooms in the garden; and art deco sconces are an enlivening touch (opposite, clockwise).

Mediterranean Style

The Mediterranean conjures images of
crystal-blue waters and endless clear skies, of white-
washed villas set against terraced hillsides. Picture
sunlight washing over stone plazas ringed with tiny tavernas
and ancient churches. There is an unmistakable smell
of the sea in the air, mingling with the fragrance of olives
and citrus.

This small, lovely villa fits right in, claiming
all the attributes of a Mediterranean getaway. The adobe
architecture, arched doorways, and keyhole windows
put one in mind of Morocco; the lush surroundings
and graceful setting suggest a house in Spain or Greece.

What matters most is the feeling evoked within: open
spaces cooled by fragrant breezes create a calm, sensual
environment; warm light and quiet inspire serenity.

Like most adobe buildings in the Mediterranean,
this dwelling has a soothing, organic feel, with rounded
edges and a handcrafted look. There is a natural, imperfect
quality to the place, giving it an inviting sense of time-
lessness. Landscaping is lavish, with tropical trees
abounding and natural stone pathways leading to secret
gardens. Palm trees, citrus trees, and bougainvillea are
dense and fragrant, filling the air with a pleasant perfume.

Inside, arched doorways and generous windows
give a feeling of spaciousness. The all-white look of the
exterior is extended indoors, where white walls, gauzy
curtains, and crisp linens create a cooling sensation. A
mix of appealing textures adds to the sensual nature of the
house: slate floors are offset by smooth stucco walls and
soft curtains; washed and worn table linens mix perfectly
with time-worn wooden dining chairs.

What to do at this calming oasis? Let whim be your
guide—a morning swim and long walk by the water;
a three-hour lunch in the shade, featuring just-picked
tomatoes, local cheese, and plenty of chilled wine;
a luxuriant siesta. At this house, as throughout the
Mediterranean, sensuality prevails, beckoning visitors
with its soft touch and palpable scents.

ALL ABOUT ADOBE

Adobe structures are made of unfired earth, the most common method of construction being the use of sun-dried bricks of mud and straw. Popular in arid climates where stone and wood are rare, adobe architecture provides simple, economical, and heat-efficient buildings. It is often considered to be vernacular or folk architecture, whose traditional use of materials and forms is indigenous to a particular region or country. Adobe forms are usually organic and rounded and often are molded by hand. Exterior walls are usually earth-colored or whitewashed and built two feet thick, with small window and door openings that provide insulation against extreme temperatures. For more information, see the Resources section, page 174.

A Moorish keyhole doorway (right and opposite) is framed by palm trees and illuminated by an ornate lantern. Bougainvillea trees create a lush feel while adding splashes of color.

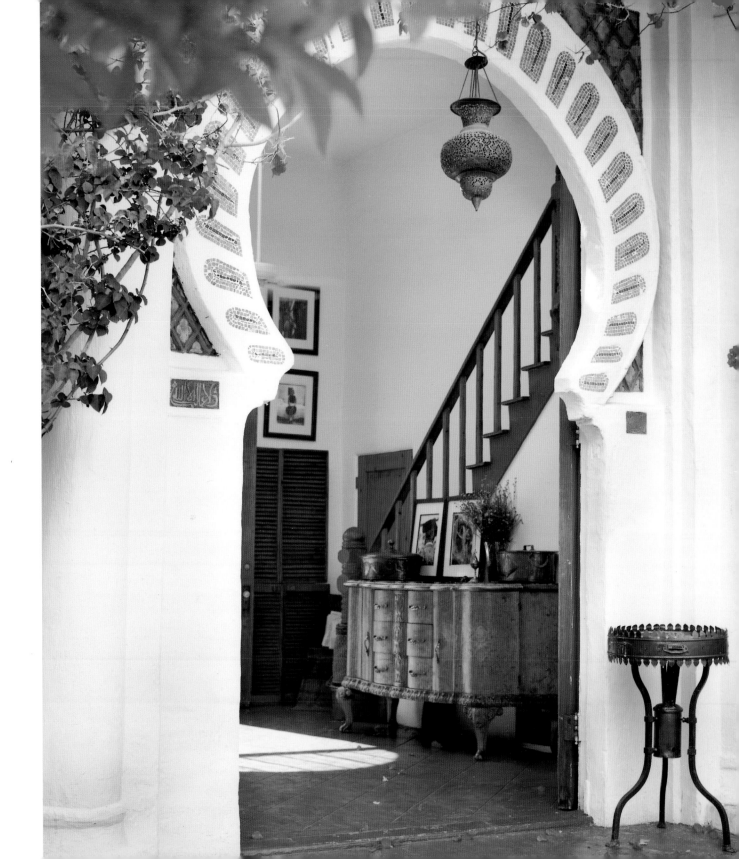

Built in a Moorish/Mediterranean style, this adobe getaway features keyhole windows and a white-washed look that puts one in mind of a Moroccan villa. The immaculate stucco exterior sparkles against a sunny blue sky.

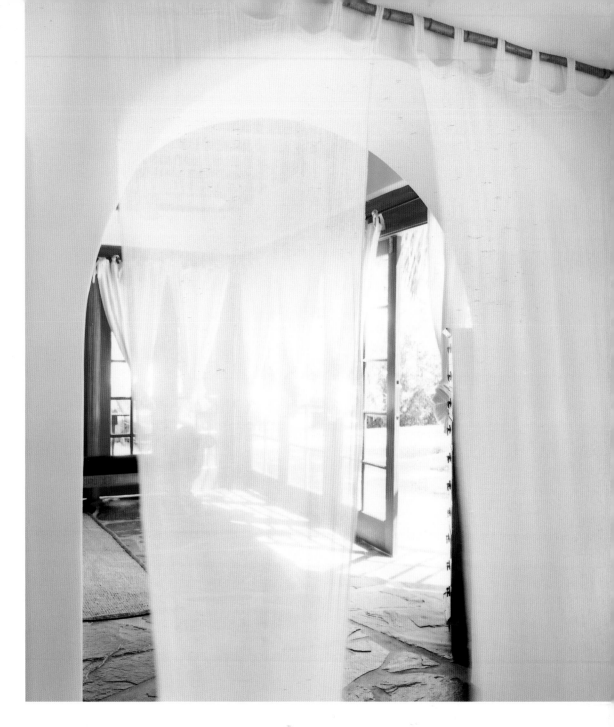

White on white is the theme at this sensual getaway. Gauzy curtains and crisp linens keep the bedroom feeling cool and breezy.

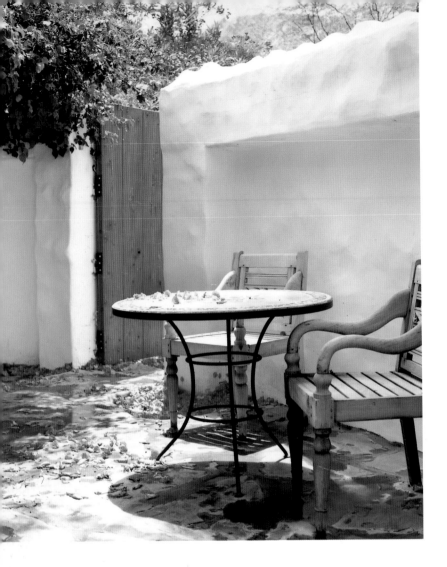

Throughout this romantic retreat, natural materials like stone, rough-cut slate, and wood are paired up with soft linens and lush flowering plants. A courtyard blanketed in bougainvillea petals (this page) is closed in by an adobe wall, allowing for quiet and privacy. In the dining room (opposite), steel windows from the 1940s are juxtaposed with slate floors and time-worn wood chairs. The result is a wabi-sabi, or casual, imperfect approach to comfortable, sensual living.

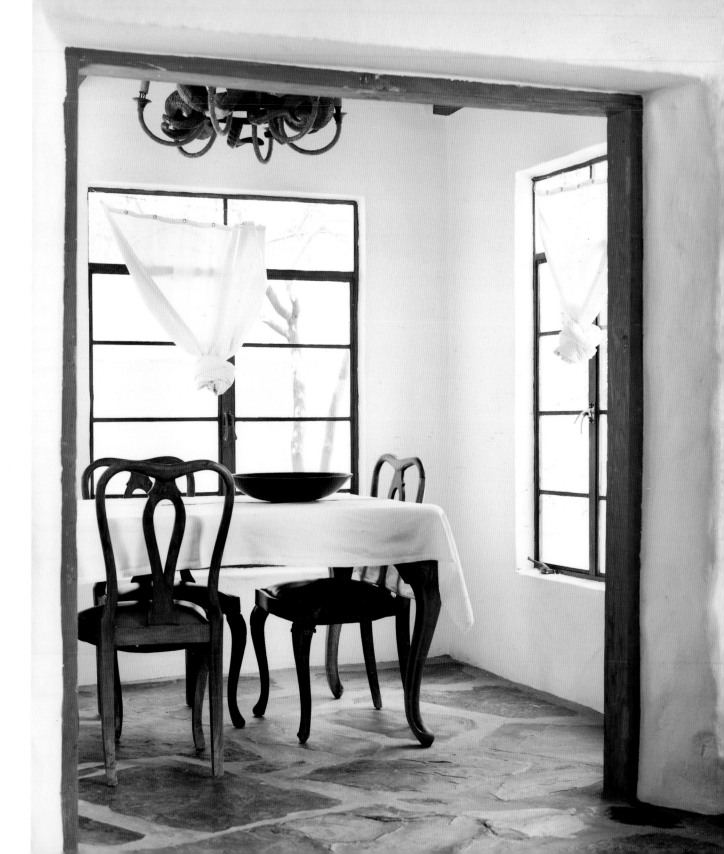

Jewel-Box Retreat

Sometimes less really is more. For this modernist retreat set on a hill and affording the utmost in privacy, less space means more sparkle. The house is of modest proportions—about 850 square feet—yet its distinguishing details and exquisite finishes make it shine.

Constructed of corrugated steel and glass, the shedlike house subtly stands out among the softness of the greenery surrounding it; the materials play well against the streamlined lap pool carved from concrete. Thanks to natural materials and a wide-open plan, the subtle geometry of the prevailing forms is welcoming rather than cold.

The play of stone, wood, and metal works well to create a visually harmonious and comfy interior. On the ground floor, the living space is outfitted with bamboo flooring and features sliding glass pocket doors in the front and back, which disappear into the walls when open. The front door leads to the patio and pool, the back exits to a small private deck.

The open kitchen features a light palette created by custom-made sycamore cabinetry and a thick slab of white Carrara marble. A cutout window above the sink brings in the green hills from beyond.

Furnishings have modern, clean lines and soft textural coverings. A carefully chosen couch and chairs sit like sculptures in the living room, offering calm by way of neutral tones. Downstairs is a sunny bedroom and luxurious bath outfitted in slate tiles and stone countertop.

Intimate outdoor seating has been carved out of the full, fragrant landscape. Two Adirondack chairs sit on the hill by a field of lavender; poolside relaxing is afforded by a deluxe cabana, elegant Japanese-style mats, and a dining table and chairs for alfresco meals.

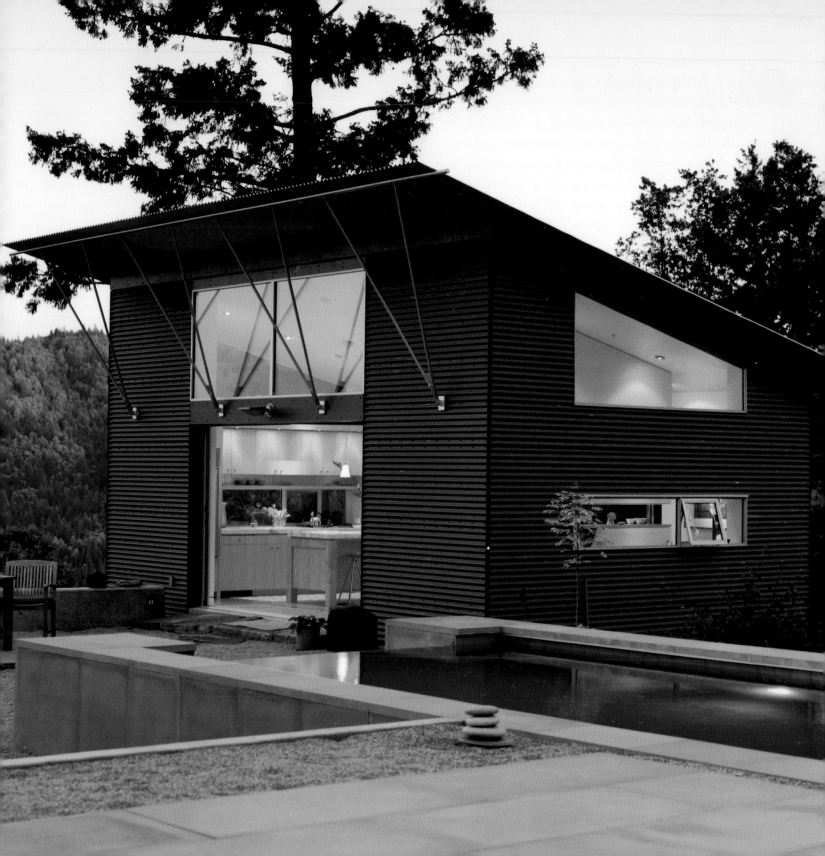

CABANAS: THE NEW OUTDOOR LIVING ROOMS

Banish the plastic pool chairs and vinyl loungers—the poolside changing room has come a long way in recent years. Our love of outdoor living and need for relief from the sun has prompted more elaborate designs for those post-swim siestas.

Here, an eleven-by-fifty-five-foot open structure was created in an appealing naturalistic style. Built of cedar, the cabana uses slats of wood and an open front for shade and to promote breezes. The modern Japanese aesthetic means that warm wood prevails, offsetting the concrete stone of the pool and the lush landscape beyond. Updated Adirondack chairs surround a low wooden coffee table; a daybed is outfitted with soft linens and plump pillows for daytime naps or overnight guests. Exotic plantings tie the area to the landscape. There is also plenty of room for a deluxe barbecue grill and lovely serving console for casually elegant outdoor dining. Opposite the cabana, tatami mats make for splendid, streamlined lounging on the carefully cut slabs of concrete. A low fire bowl powered by propane and filled with sand is a dramatic statement in the evening.

A lounging area by the pool (right) is fashioned from simple tatami mats and a sand-bowl fire pit powered by propane.

(opposite, clockwise) Adirondack chairs painted cobalt blue cozy up to a lavender field; an outdoor sleeping area in the Japanese-inspired cabana houses sunbathers and overnight guests; an artificial waterfall by the pool's edge creates soothing sounds; a concrete niche in the bathroom gives a naturalistic feel.

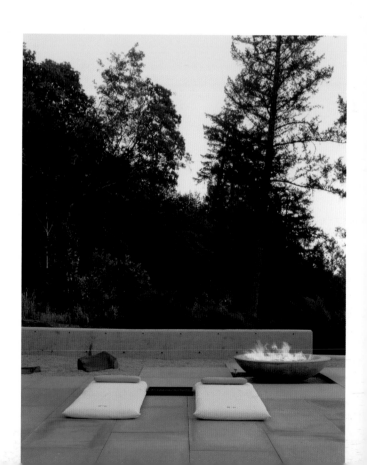

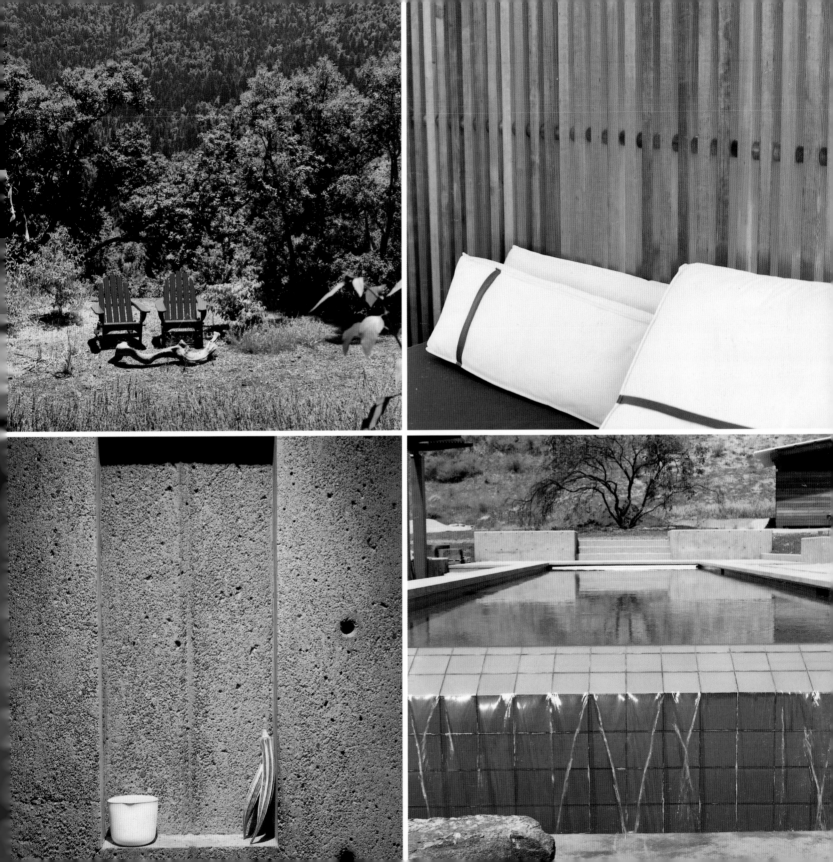

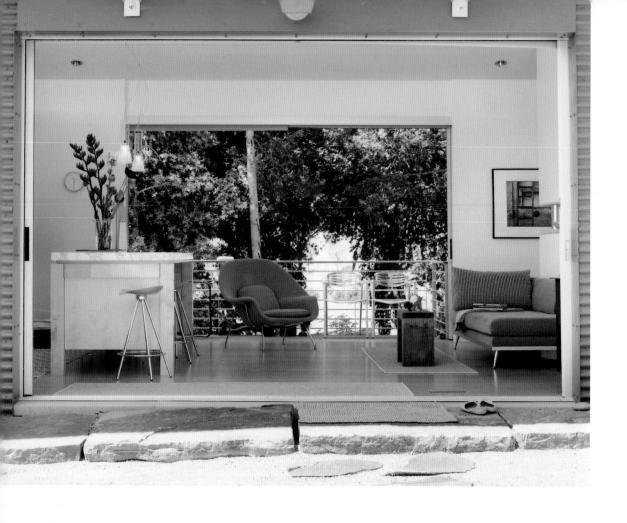
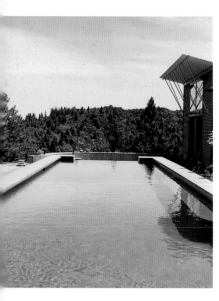
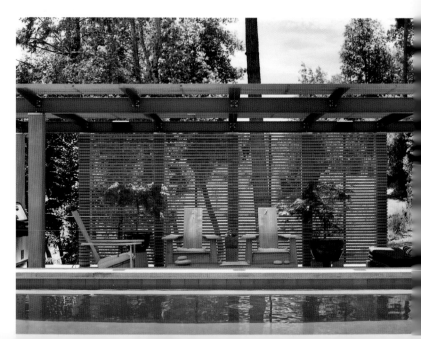

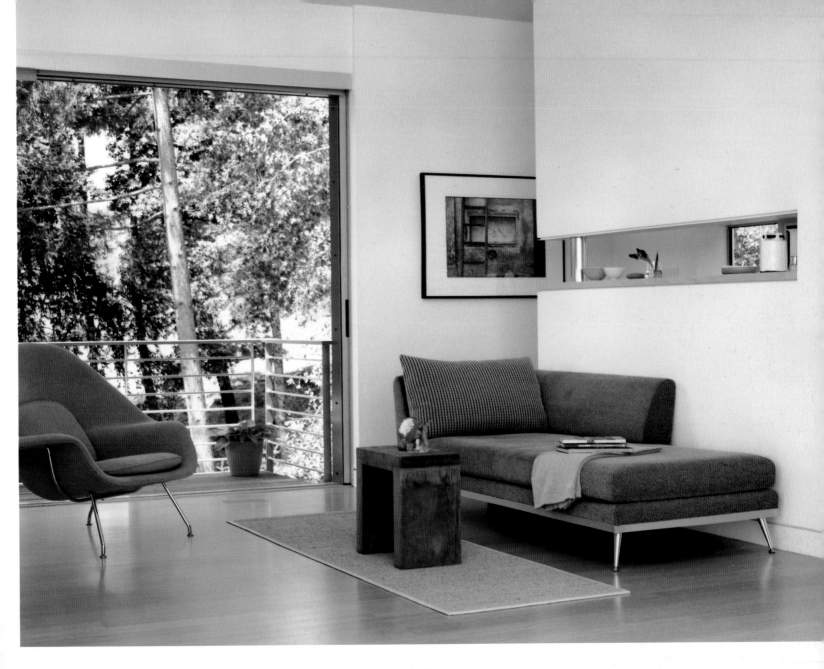

High-quality finishes make for sparkling interior rooms. In the living room (opposite, top and above), bamboo flooring is a warm backdrop for the modernist furnishings.

The poolside cabana (opposite, left) is a generous 600 square feet. Built of cedar slats, this outdoor living room promotes shade and breezes. Updated Adirondack chairs surround a low wooden coffee table.

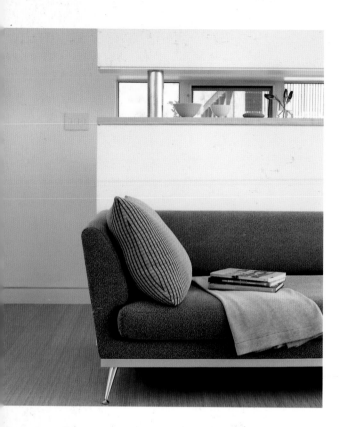

A horizontal cutout in the living room wall brings even more light into the room from the window beyond.

The kitchen island is topped with a thick slab of white Carrara marble, beautifully offsetting the custom-made sycamore cabinetry.

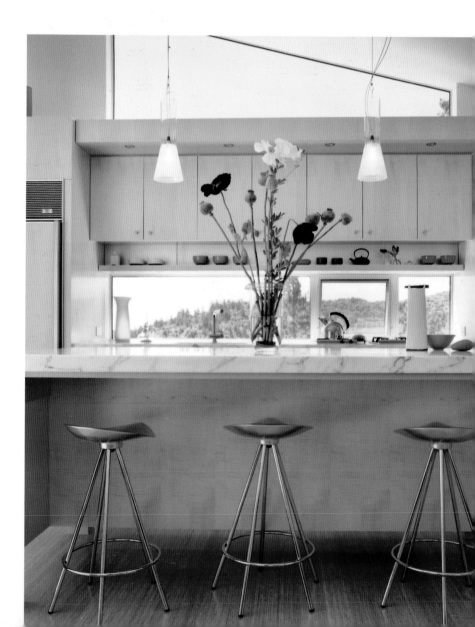

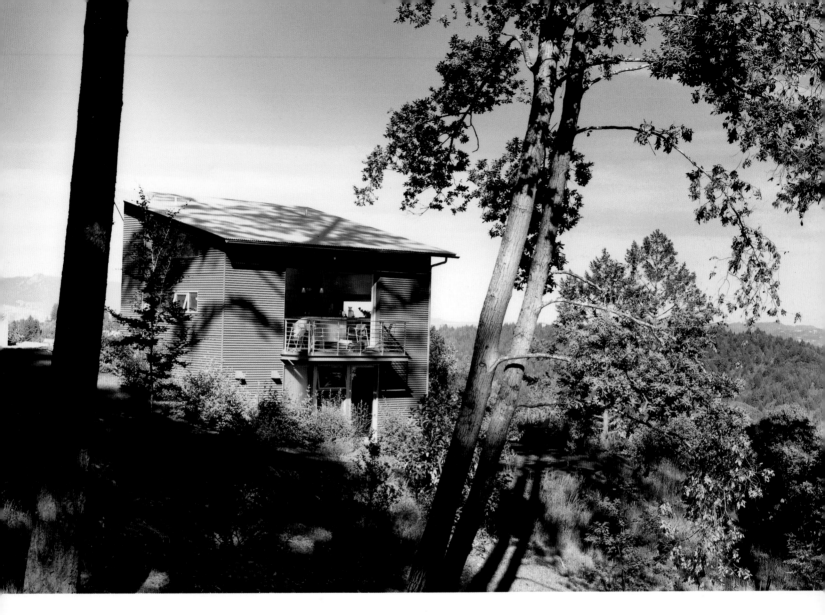

Constructed of corrugated steel and glass, the shedlike house subtly stands out against the lush landscape surrounding it. The house's terraced design places public rooms above and a sleeping area and bath below; windows on either side of the house ensure light and views.

Reinventing the Barn

From the side, this secluded weekend getaway built into a hillside and surrounded by lush country has the classic proportions of a barn, with its wide double door, pitched roof, and central second-story window. Even the cladding—corrugated metal—recalls early agrarian buildings.

Inside, the open living space, with its double height and pitched ceiling, does much to extend the metaphor. A large open kitchen, communal wooden table in the dining room, and chandelier fashioned from deer antlers also carry on the theme.

This subtle nod to country tradition mingles well with a thoroughly modern sensibility throughout the house. Large sections of glass windows look out onto the pool and arbor beyond, and there's easy access to outdoor living spaces. The floor is concrete and the furnishings spare and soothing; a near-professional kitchen indoors and cooking facilities outdoors mean plenty of opportunity for entertaining.

The house is embraced by a flourishing landscape. Scrub oaks, manzanitas, and madrone trees perfume the air. They are a stunning backdrop for the dramatic pool, a virtual living room unto itself, with generous lounge space and lush plantings surrounding it. For entertaining, there is a wood-fired brick pizza oven, a refrigerator, and a bar area, along with an oversize table for dining.

The guesthouse takes on a streamlined aesthetic that allows for privacy within a one-room living space. Situated below the pool, it is essentially a rectangular block of a house. Beautiful detailing adorns the open room: built-in cabinetry has a light, reflective palette, as does the sparkling Carrara marble. Furnishings are minimal; a Murphy bed pulls down when needed. An entire wall of sliding glass doors opens the house up to the greenery beyond and floods the space with bright, warm light.

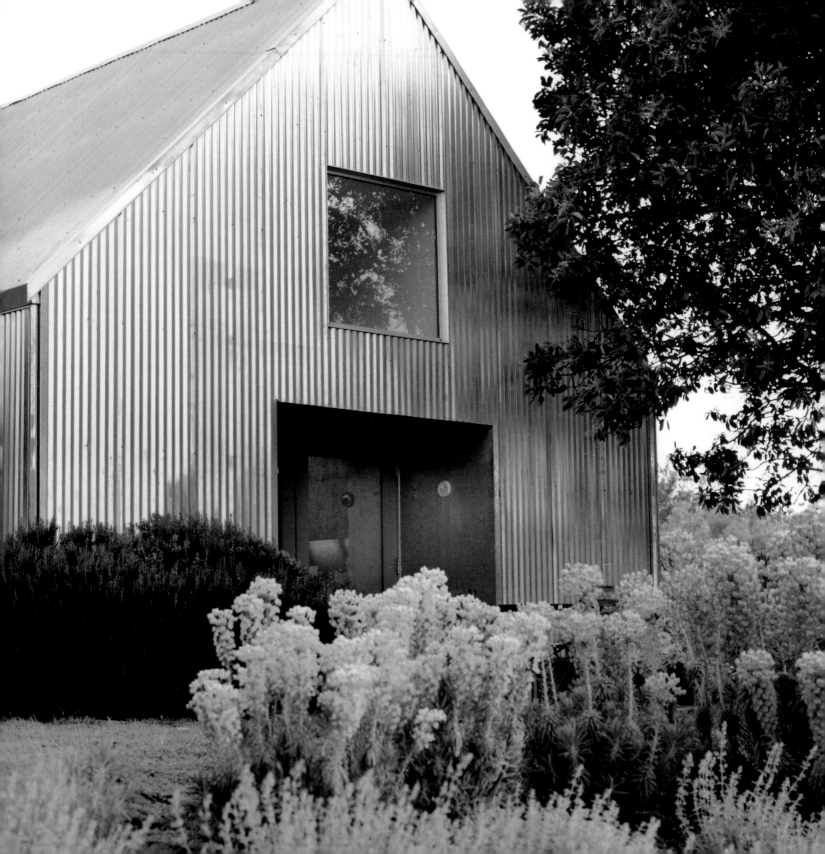

DESIGN DETAIL:
CORRUGATED METAL

Traditionally used on agrarian buildings such as barns and stables, corrugated metal is experiencing a newfound popularity in architecture. Its crisp, modern lines make it a pleasing choice for many different kinds of buildings. Practical and inexpensive, corrugated metal is both a nod to the past and a celebration of an easily obtainable, mass-produced material.

Clad in corrugated metal, the house's facade (right) contrasts well with the lush landscaping that surrounds it (opposite, right). The structure commands subtle attention from its vantage point on a hill (opposite, left) overlooking the pool and the verdant valley beyond.

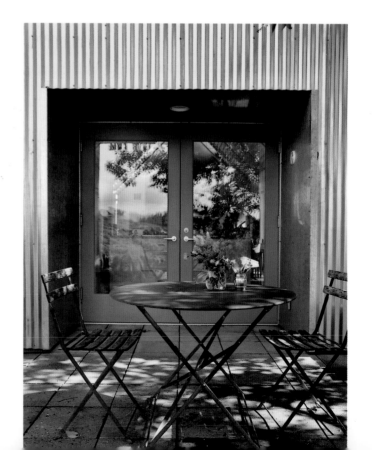

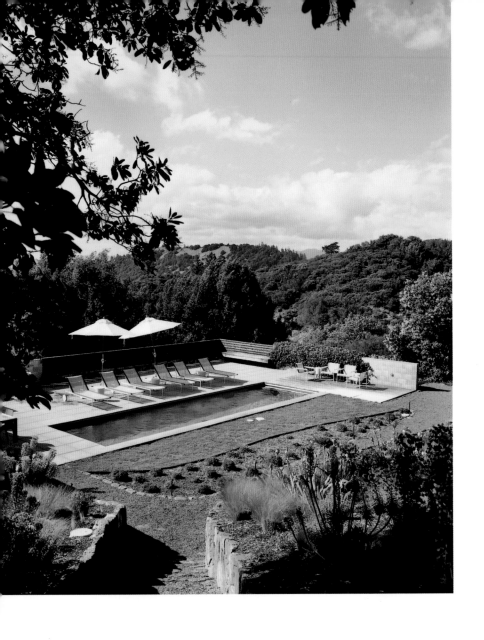

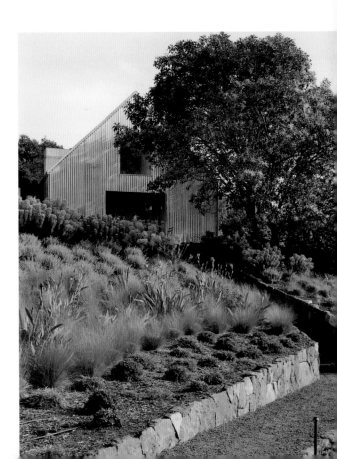

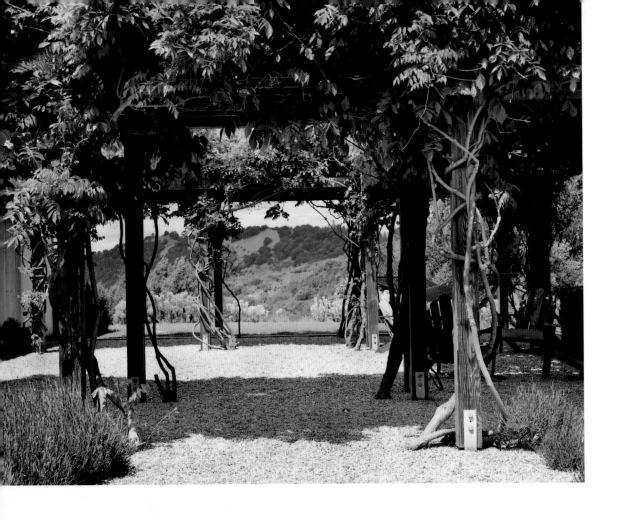

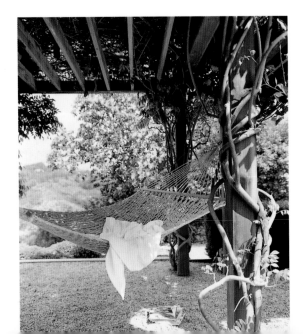

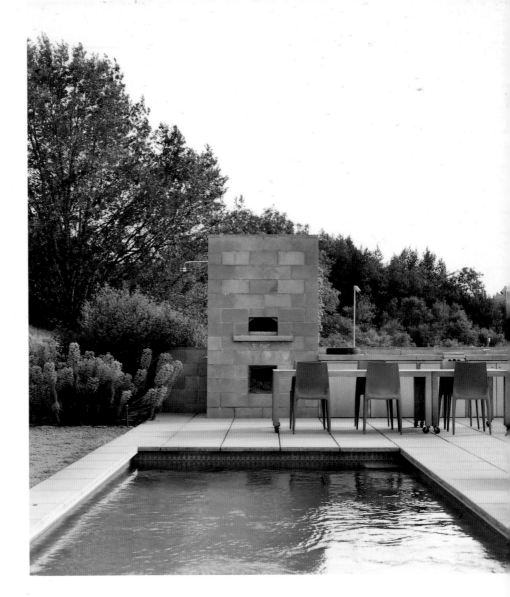

A lush arbor covered in wisteria and grape vines softens the entryway to the house, where a hammock awaits would-be nappers (opposite). The entrance to the guest house (left) is hidden beneath the pool, affording the utmost in privacy. A dining area by the pool (above) is centered on a wood-burning stone fireplace and wet bar.

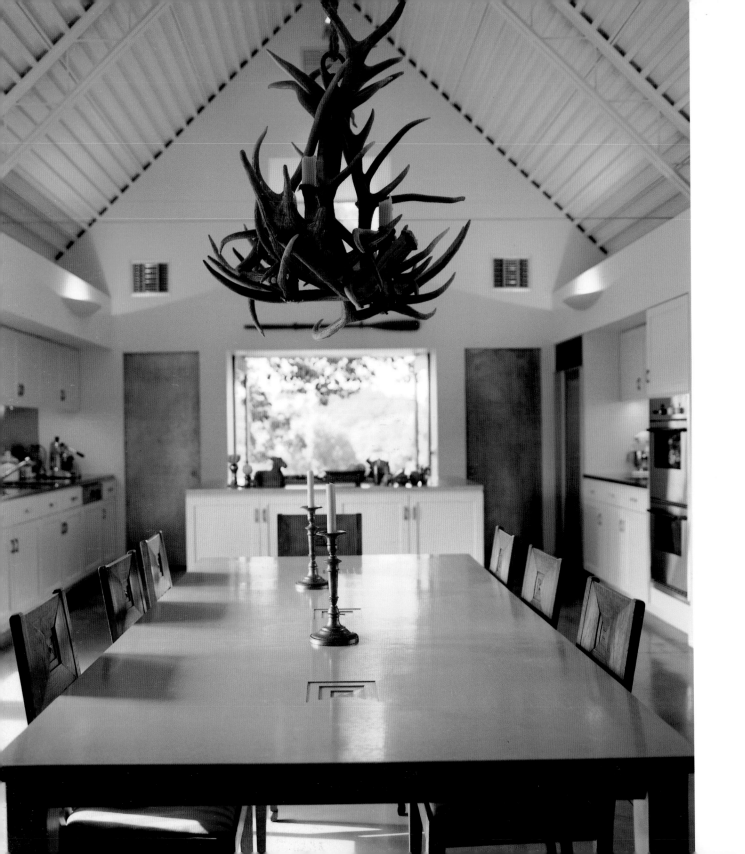

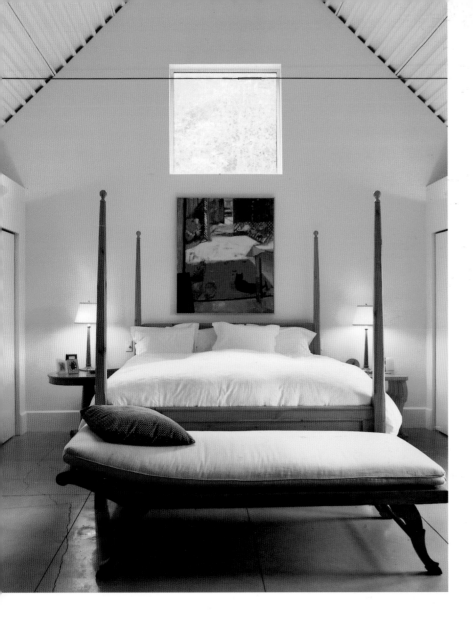

The house's distinctive pitched roof puts one in mind of a barn, but with a modern twist. The open kitchen (opposite) features sleek finishes like stainless steel; in the dining room, wood prevails. The bedroom (left) contains large built-in closets for a clutter-free look; the upstairs study (below) is modern and spare.

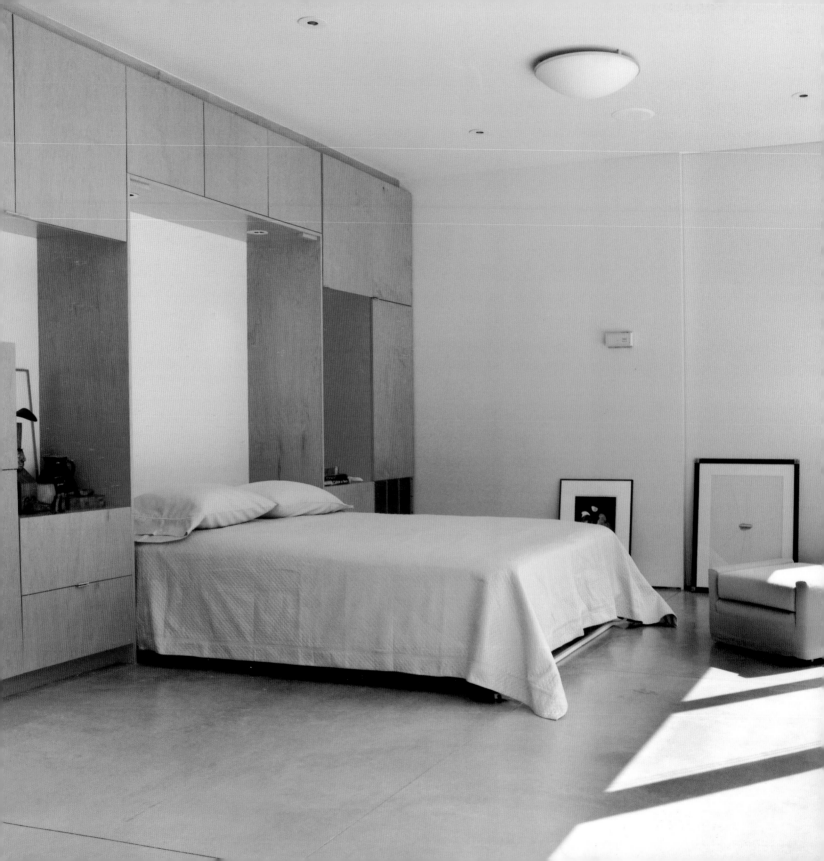

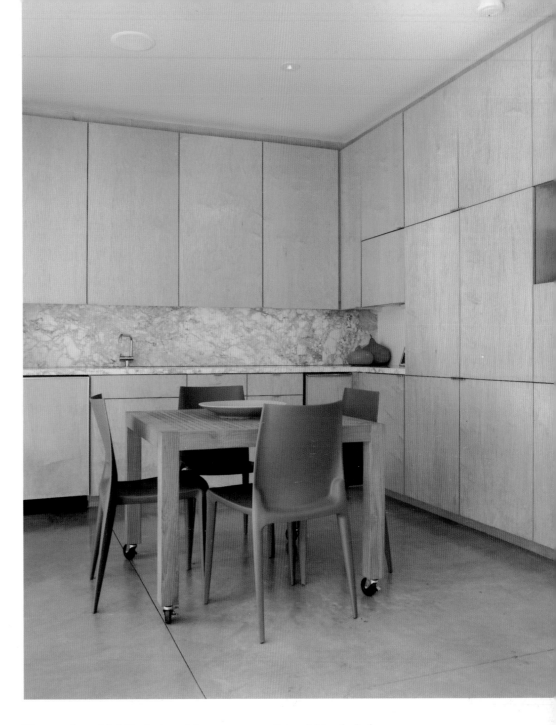

The guest house's loftlike design celebrates one-room living. A Murphy bed (opposite) can be tucked away for extra space; built-in cabinetry keeps all belongings and kitchenware out of sight. Concrete flooring (above) keeps the space cool while sliding glass doors bring light into the room.

Gentle Geometry

Building a house to complement the forms of nature can sometimes yield surprising results. Contrasting the lush rolling terrain of this property, a rectangular house of straightforward lines and blocklike volumes seems the perfect foil for the site. The dramatic structure is defined by stucco, steel, and glass. With its boxy profile and rectangular windows, the house suggests a Mark Rothko painting—a poetic abstraction in nature.

The house has two faces: the side facing the road is marked by a large Cor-Ten steel wall that takes on a bright red cast, offering a stark contrast to the plentiful plantings that surround the property. In back, walls become windows that open onto the landscape, bringing the outdoors in. The thousand-square-foot home also has two interior courtyards.

The inside of the house is open, airy, and defined mostly by glass; large windows throw big blocks of light into the space. A combined kitchen, dining, and living area is furnished sparsely with modern pieces that stand like sculptural forms in the whitewashed expanse. Vibrant paintings add touches of color throughout.

In the bathroom, privacy is achieved without the loss of light. The large, fully tiled room is enclosed by walls of frosted glass that help define a "wet" room housing an open shower, toilet, and sink. Blue tile that can just be seen through the glass creates a calming feeling of being at the seashore.

With so many sculptural forms presiding, a sense of harmony between art and nature is palpable throughout this unique retreat.

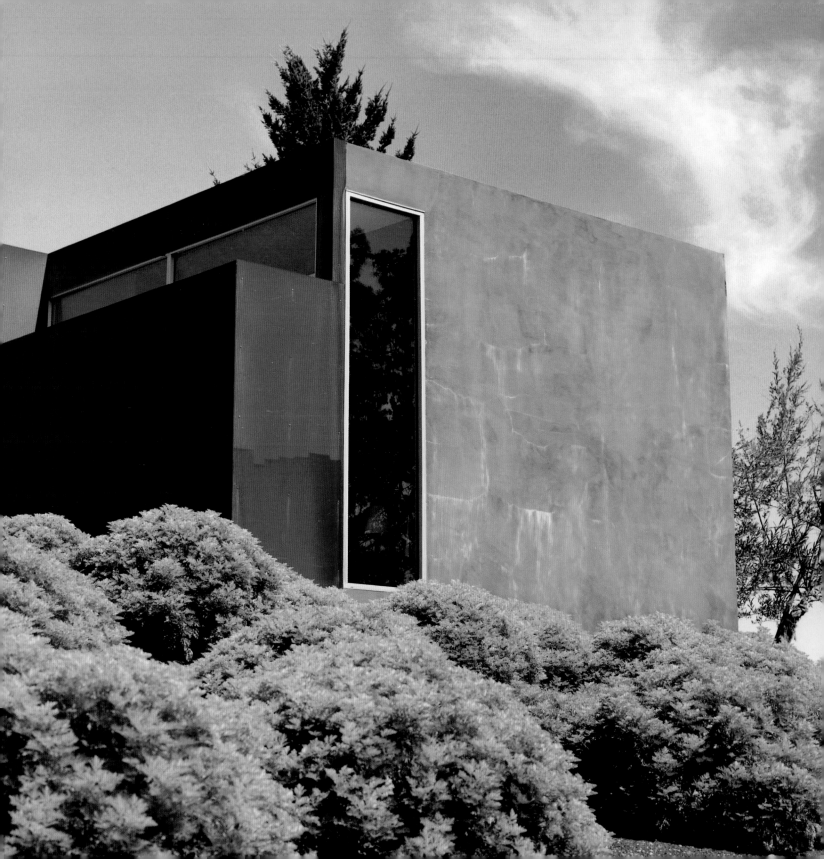

DESIGN DETAIL: COR-TEN STEEL

In keeping with the rising popularity of industrial materials in architecture, the use of Cor-Ten steel is growing. Often used on exterior walls, Cor-Ten is a special type of steel designed to weather or age to give a pleasing coppery color that intensifies with time. If left untreated, Cor-Ten will oxidize to form its own protective patina of rust. Cor-Ten's main advantage is its resistance to corrosion, and for this reason it is mostly used in bridge building, marine-vessel fabrication, and outdoor sculpture, such as in the work of Richard Serra. For more on Cor-Ten, see the Resources section, page 174.

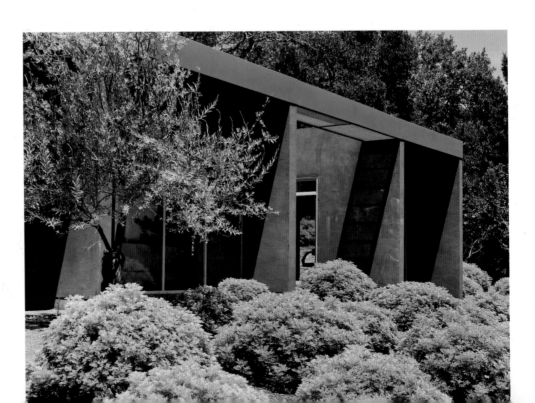

A lushly landscaped lap pool (below) is one of the boons of this
secluded, streamlined getaway. At the edge of the pool, an expansive
view of the valley opens up to bathers. The house's concrete backside
(opposite) is sectioned to create shady courtyards.

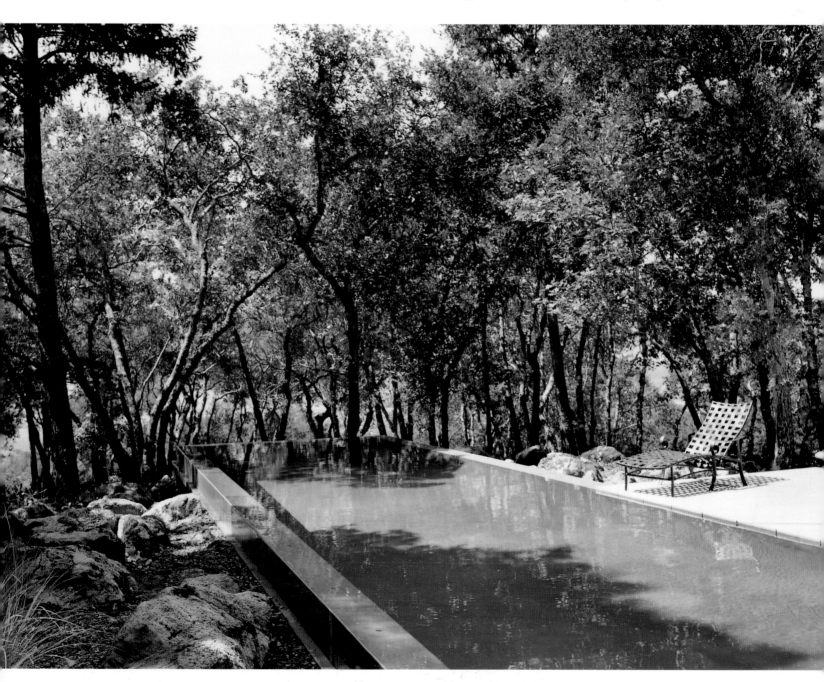

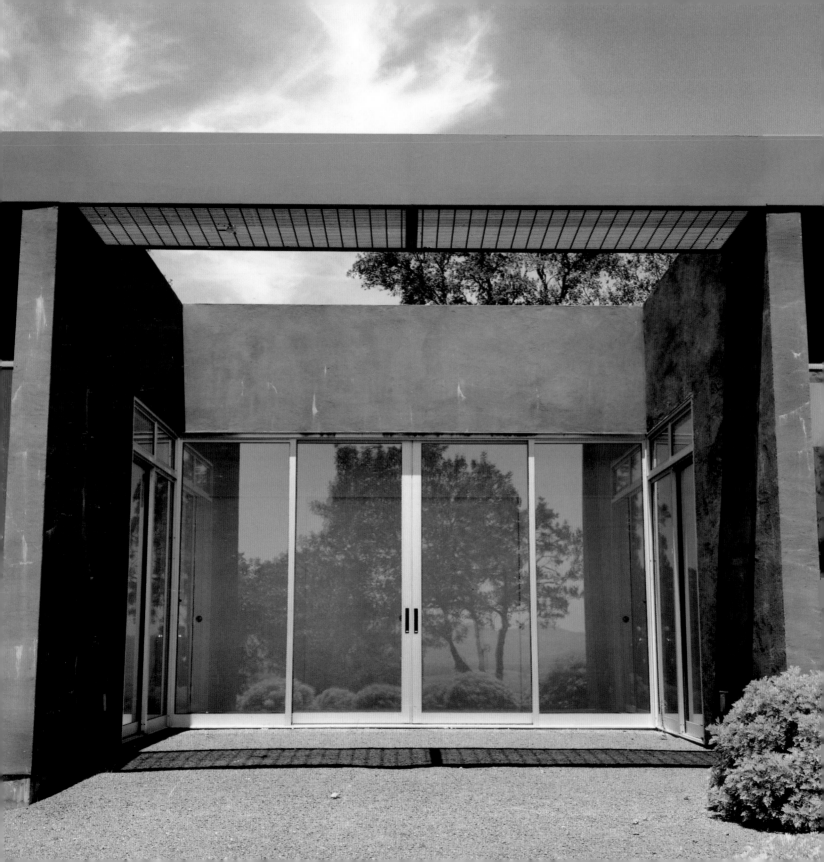

A series of glass doors creates a "window on a window" effect (below) playing up the importance of openness and views. The back of the house (opposite) is open to the elements, with glass doorways that let in warmth and light.

A curved sofa (above) allows for plenty of seating within the large open living–dining–kitchen space, where comfort and versatility are emphasized. An open kitchen (above right) facilitates cooking and conversation; stools allow guests or family members to join in the culinary goings-on. Skeletal wood furnishings (right) outfit the home office.

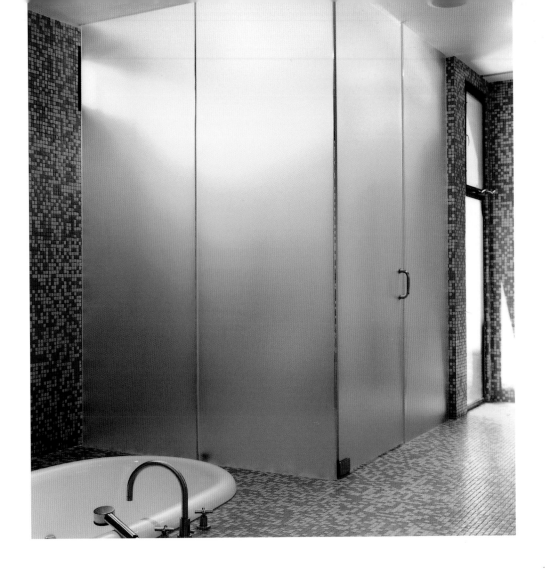

Frosted glass in the bathrooms promotes privacy without sacrificing light; tilework is reflected throughout the spaces to bring color and texture to the rooms.

Desert Modern

With its vast open spaces and extreme climate, the desert is beckoning and beguiling. Funky flora—from palm trees and curious cacti to odd-looking grasses and ground-hugging scrub—can give the feeling of being on another planet, or at least a movie set from *Star Trek*. Fauna, too, surprises: roadrunners scurry while lizards slither about; jackrabbits share space with coyote and bobcat.

Not everyone would choose to place a weekend house smack in the middle of the desert, but the landscape offers an intriguing foundation on which to build. Here, the austerity of the terrain is just the right backdrop for a modern house that takes design cues from the land itself. Originally built as a homesteader's cabin in the 1950s, the structure has been cleverly converted into a beautifully appointed weekend home. With just 366

square feet, the one-room house celebrates outdoor living, with even more space under the sky than indoors. The patio takes in the view of the desert landscape; in back is a secluded area for outdoor bathing. With sliding glass doors at both ends, the feeling of the house is airy and spacious.

The home fits in naturally with its surroundings: an earth-toned palette picks up colors found outside; textures are varied and tactile. Built of stucco, the house's exterior is a sage green that mimics the hue of the landscape. The trellis in front is made of warm Douglas fir wood. Inside, natural materials, particularly exotic woods, define the space. Custom cabinets were fashioned from eucalyptus; countertops are of pale green limestone.

The layout of the house is configured to allow space for sleeping, cooking, dining, and bathing. The dining area, framed on two sides by picture windows, includes a Murphy bed paneled in eucalyptus wood. The sleeping area has built-in bookcases and closet space; the kitchen, with its counter seating, is the main gathering spot in the house.

Methods for keeping cool are a must. Black-out shades, kept drawn during midday, keep the heat and glare at bay; concrete flooring helps keep temperatures down inside. An outdoor trellis over the patio provides relief from the harsh summer sun without obscuring the view. Windows on opposite sides of the dwelling encourage cross breezes. A large indoor-outdoor shower and outdoor tub invite frequent, leisurely bathing.

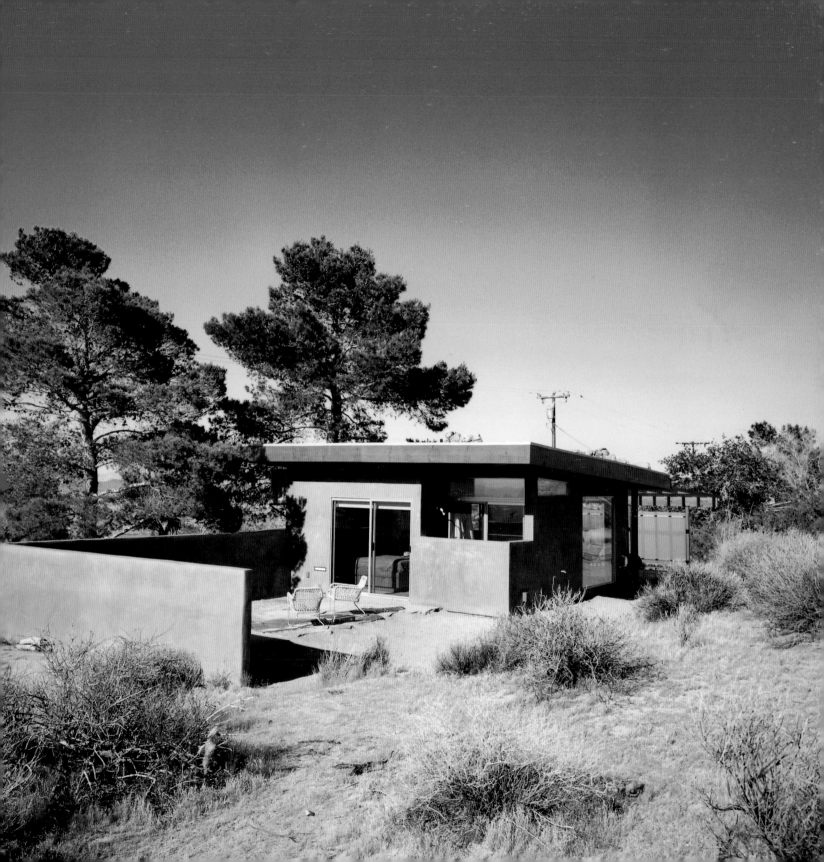

DESERT LIVING

For climate control indoors, swamp coolers are often the method of choice. These evaporative coolers provide a low-cost, low-technology alternative to refrigerated air conditioning. A swamp cooler is essentially a large box containing a big fan and water-wetted pads, usually made of aspen wood fibers. Fresh outside air is pulled in through the moist pads, where it is cooled by evaporation and circulated through the house by the fan, lowering indoor temperatures by up to 25 degrees.

Because temperatures and dryness levels in the desert often reach extremes, some basic precautions must be taken. For comfort and safety, it's important to keep moisturizer, sunscreen, bug spray, sunglasses, a sun hat, and plenty of water on hand. It's best to stay indoors during the hot midday hours; early morning and evening are good times to enjoy the outdoors or engage in physical activity. For more information on desert living, see the Resources section, page 174.

The house's low profile and neutral palette fit in well with the desert landscape.

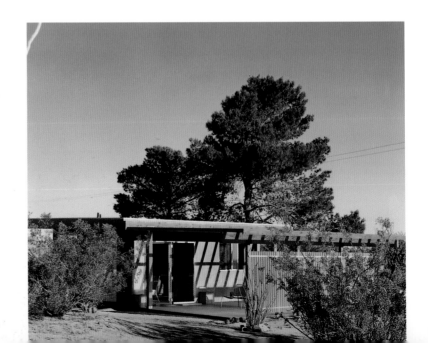

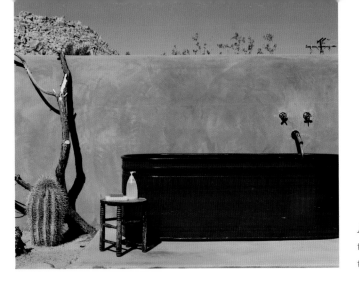

A private bathing area (left) is marked by a stucco wall and a converted horse trough. A corrugated acrylic transparent panel keeps heat out but lets light into the front patio (below) where woven furnishings make a welcome resting spot.

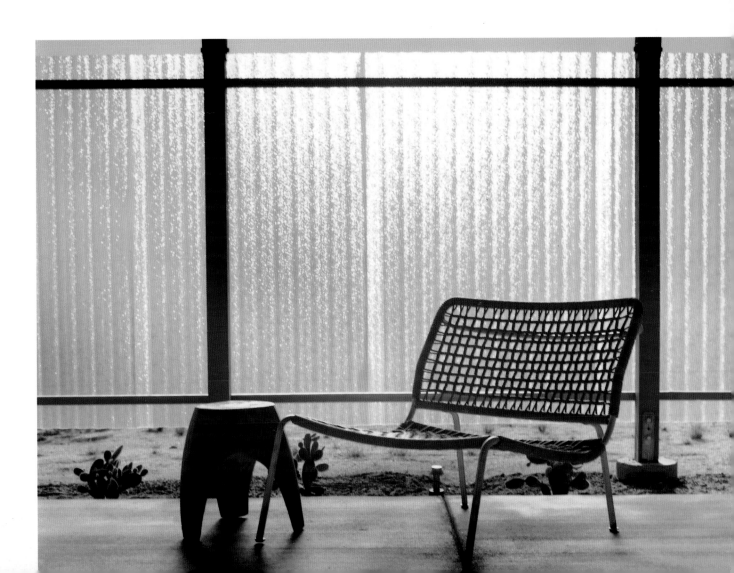

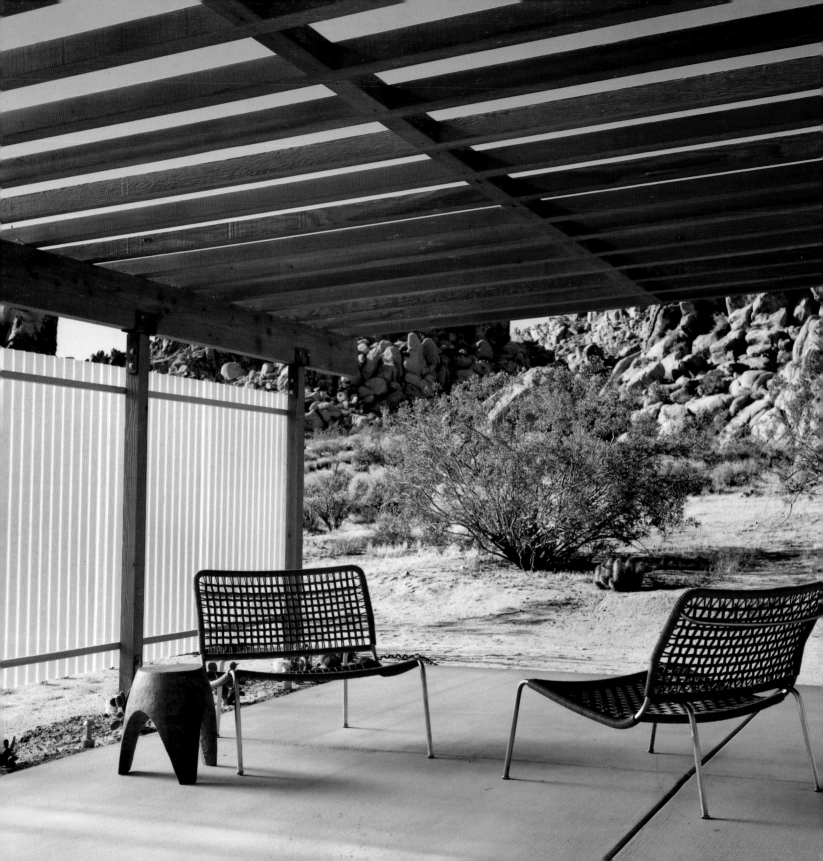

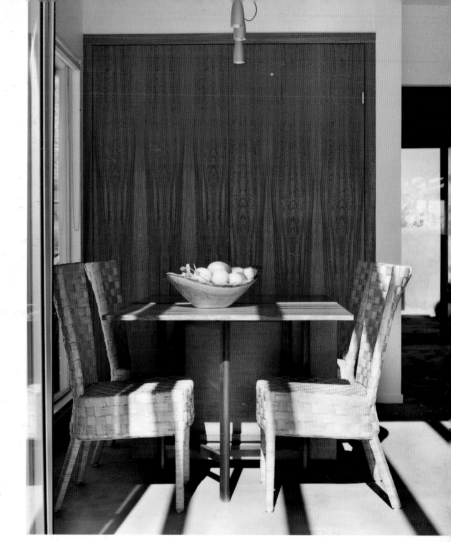

Acrylic panels, a Douglas fir trellis, and concrete slabs make for a cooling patio (opposite) in front of the house. The Danish modern dining table (right) folds up to just five inches.

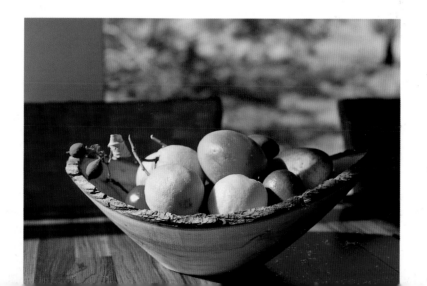

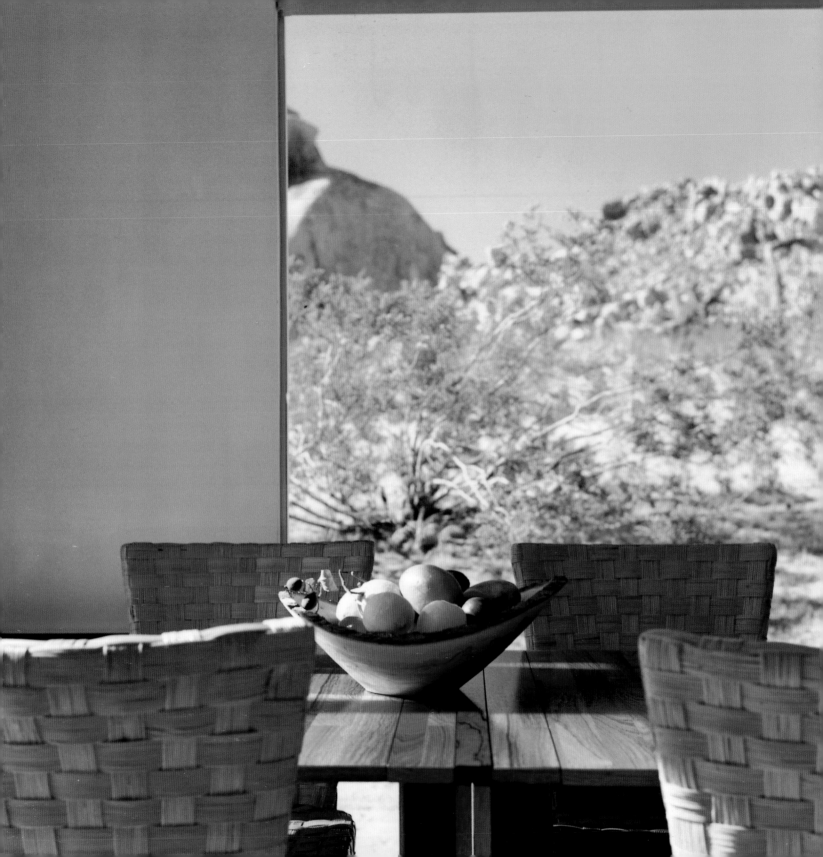

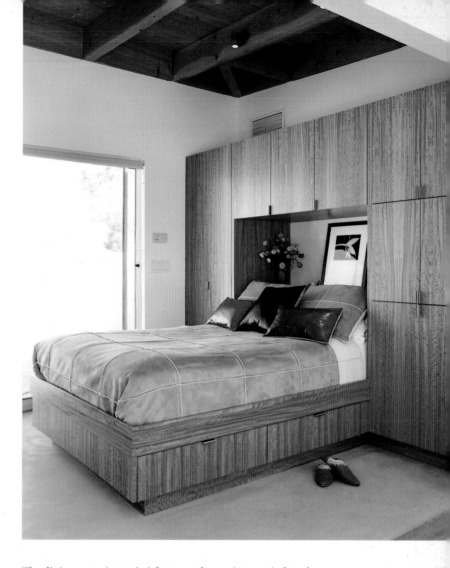

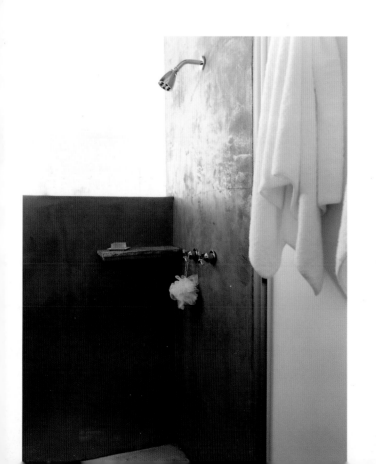

The dining room (opposite) features a large picture window that brings in the exotic landscape beyond. The room also features a Murphy bed to house extra guests. A limestone countertop (above left) is set up with leather and metal stools for impromptu refreshment; an indoor-outdoor shower (left) is walled in concrete. The sleeping area (above) features custom-made eucalyptus cabinetry that keeps clothes and belongings out of sight.

Waterfall House

Silence is golden, and nature often delivers it—but not when you live on top of a waterfall. Here, the persistent roar of the falls creates a layer of sound indoors and out that can be both soothing and exhilarating. It is a daring yet intimate communion with nature.

Building a house on such a dramatic site required a careful plan for a building that would coexist with nature but not overtake it—or be overtaken by it. The vision for this hundred-acre property accomplished just that, with shady groves and scenic vistas punctuated by lily ponds, footbridges, and intimate paths. The compound comprises a total of nine wood-frame, pavilion-like buildings, including a main living space, an architectural and painting studio, and a guest and pool house.

The main house is a copper-roofed glass edifice perched fifty feet above the ground, atop a three-story concrete structure adjacent to the waterfall's dam. The building encompasses two levels for bedrooms and one for a screening room. With glass walls that fit neatly into pockets, the main living space—an open kitchen, dining area, and living room—opens onto the falls, with staggering views of the water and woodlands beyond. Dark mahogany was chosen for the framing and ceiling and unpolished granite for the floors to create a soothing, contemplative mood.

A flagstone path leads out to a sitting area at the top of the falls, from which one can survey a 360-degree view of the landscape. Sitting here, one has the sensation of floating on water, suspended halfway between the grounded structure of the house and the infinity of nature. It is a peaceful and rarely afforded perspective.

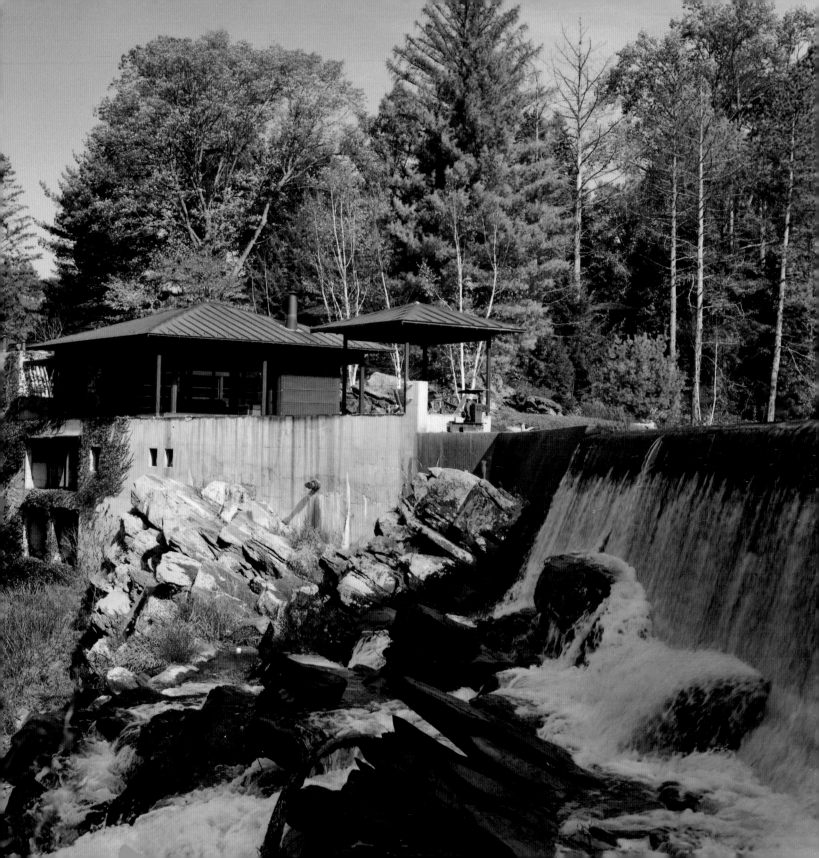

FALLINGWATER

The most famous waterfall house in the world is Frank Lloyd Wright's Fallingwater, in western Pennsylvania, voted by the American Institute of Architects as the best all-time work of American architecture. Each year, thousands of visitors come to this remote location to visit the landmark. Completed in 1939, the house was designed on the principle that humans and nature should coexist harmoniously. To that end, Wright cantilevered the house over the falls in a series of concrete ledges. The house extends thirty feet above the rock ledges and hovers over the rushing mountain stream. Wright said of the house, "You listen to Fallingwater the way you listen to the quiet country." For more information, see the Resources section, page 174.

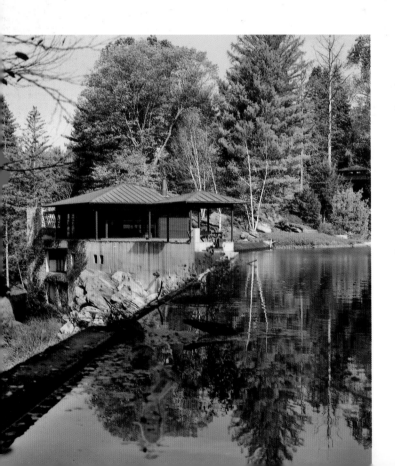

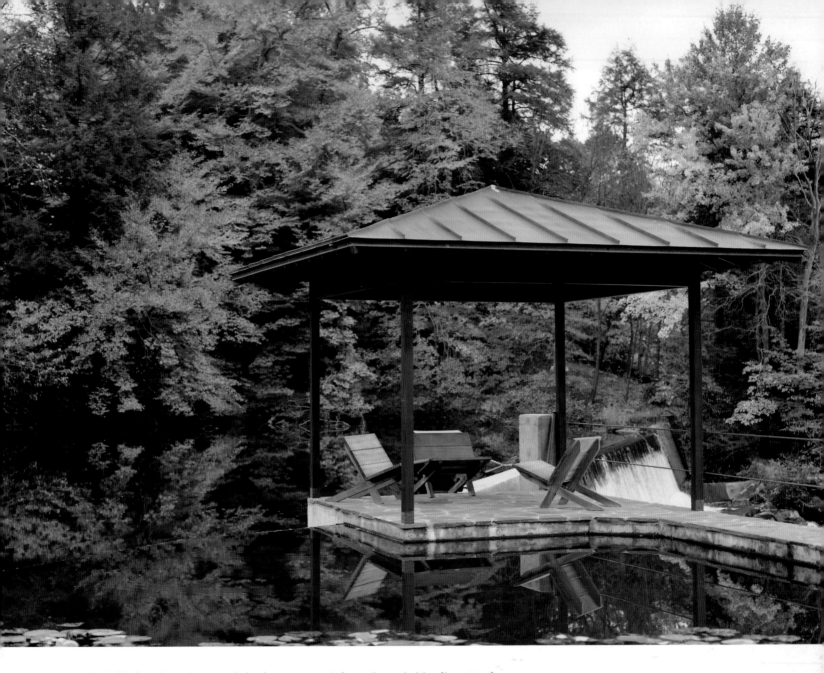

Perched fifty feet above the ground, the three-story main house (opposite) is adjacent to the waterfall's dam. A flagstone path leads from the main house to a floating outdoor pavilion (above) where one can watch the seasons unfold via a 360-degree view of nature.

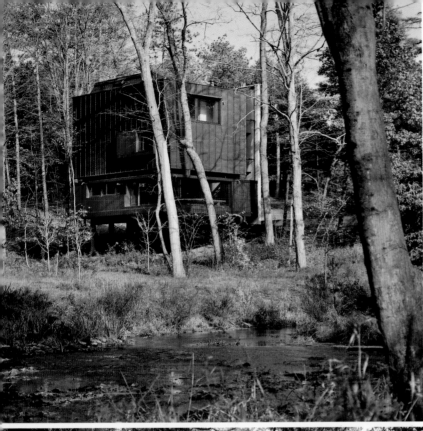

An architectural studio (left), housed in a separate building from the main house, is a three-story structure on stilts with vertical wood slatting and tall windows to emphasize the columnar shape of the surrounding trees. A wood suspension bridge (below) leads to guests' quarters and a pool house.

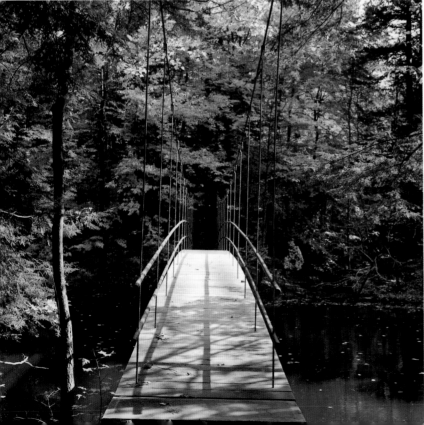

Glass-walled windows in the living room (right) function like pocket doors to reveal the power and expanse of the falls just outside. At times, the water is so loud it drowns out normal conversation. The owner's architectural studio (below) is a place in which to draw inspiration from nature, with only minimal furnishings and a wide-open view of the surrounding landscape.

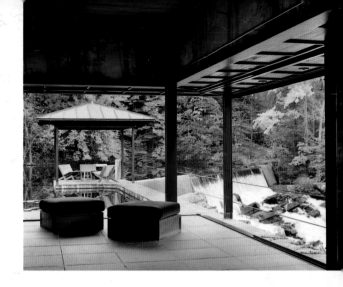

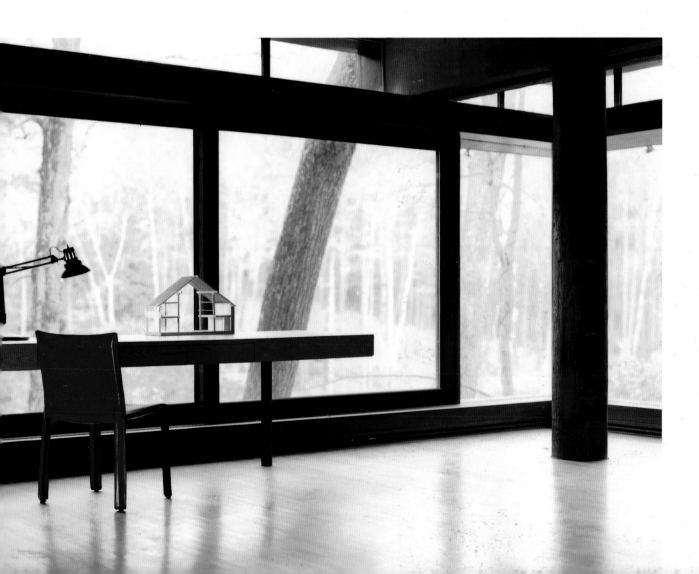

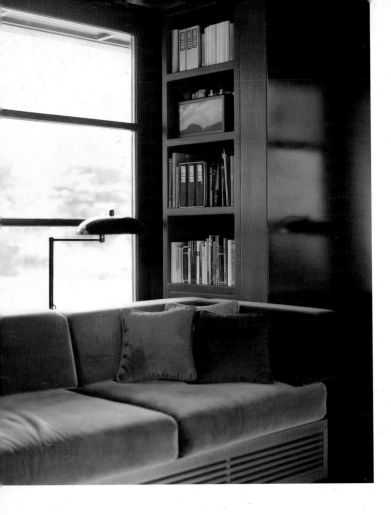

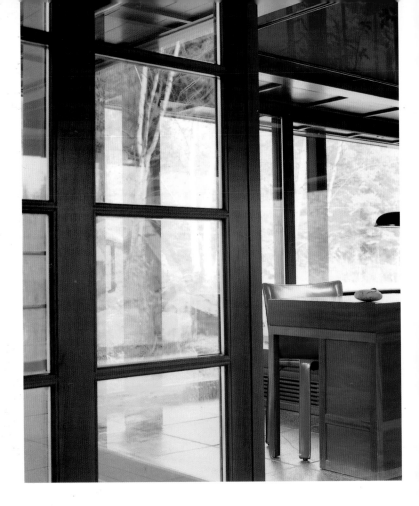

A plethora of wood and glass in the living and dining areas gives the space a warm, open feel. A reading nook in the living room (above left) makes for a cozy corner; a work area (above) is flooded with natural light. Unpolished granite flooring and dark mahogany on the ceiling make for a quiet, contemplative sanctuary (opposite), where a marble Buddha dating from the eleventh century resides.

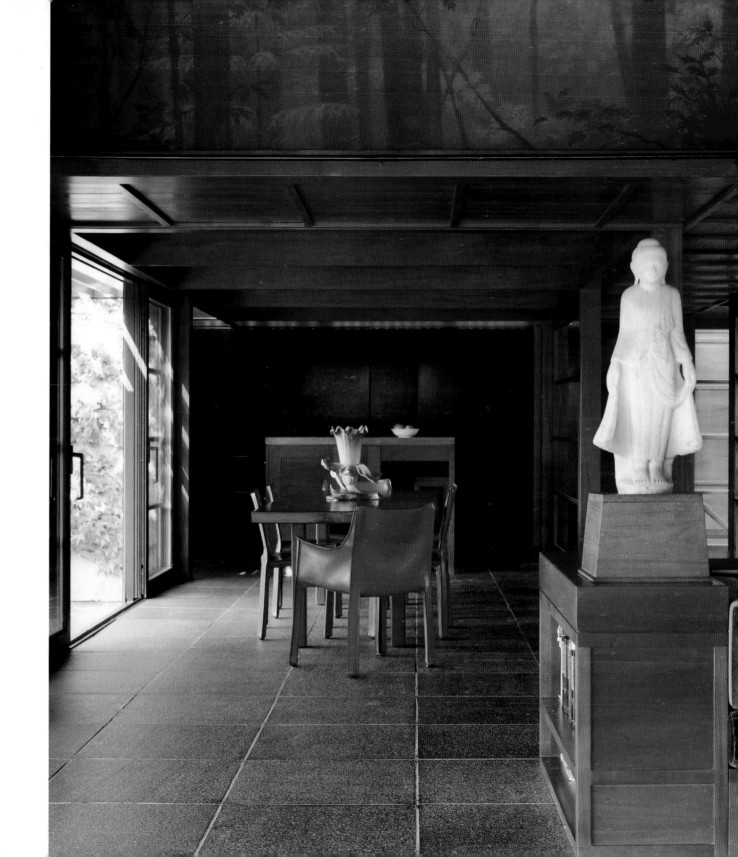

Letting Light In

The quality of light in nature is ever changing, and it seems the farther away from "civilization" we get, the more spectacular the show—dappled sunshine through fiery autumn leaves, a meadow made golden by brilliant light, shimmering reflections on a sparkling sun-washed lake.

Light and views are perhaps the most breathtaking aspects of living in the country. This retreat capitalizes on both, thanks to careful siting and design. The house is essentially a simple structure that mimics the rectangular shape of its plot and takes advantage of the views, but doesn't overwhelm the site with its boxy shape. For inspiration, the architect looked to structures she admired, from the garden pavilions she visited in Japan to rustic, weathered American barns.

Made primarily of wood and glass, this house is like a modern shed. Natural materials were declared a must, so the house is clad in Douglas fir with teak doors and window frames and Ipe-wood decking. The structure takes on a warm, rich tone that in autumn matches the vibrant glow of the foliage outside. Inside, the natural palette is continued with oak and concrete flooring. An open staircase of repurposed Douglas fir joins the living area downstairs to the bedrooms above.

Privacy was also deemed key. A gravel footpath places the house far off the road, and the entrance to the house is via a wooden footbridge. Surrounded by cherry, oak, and locust trees, the house seems to nestle into the knoll.

Country life brings simple pleasures, and one of them is a deep bathtub facing eight-foot-wide sliding glass doors that look out onto the mountains. Inspired by wooden soaking tubs in Japan, the bath surround is teak, a naturally water-resistant wood. The floor features handmade arts and crafts tile.

With so many windows, this hideaway takes in a 180-degree view that reveals a dramatic natural display. The mist in the valley changes each morning, as do the evening sunsets. Each window offers a different visual experience: treetops, fields, faraway hills, and clouds.

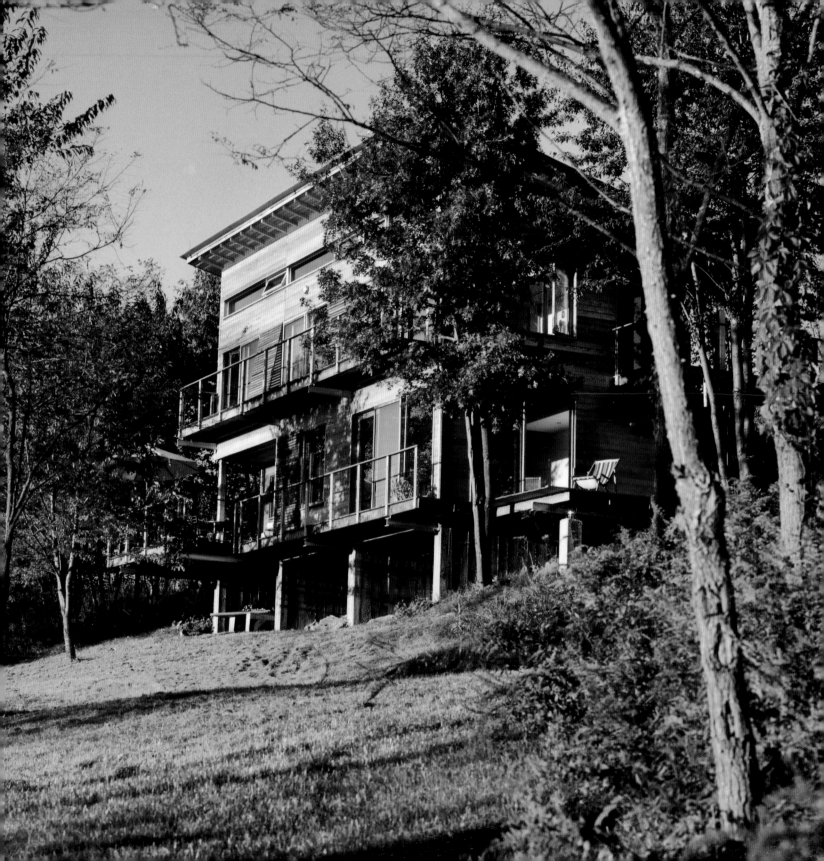

DESIGN DETAIL: IPE WOOD

Ipe, or ironwood, is fast becoming the wood of choice for outdoor decking. Harvested only from sustainable forests in South America, it is an environmentally responsible wood that naturally resists rot, decay, insects, and mold without the toxic chemicals that are used in other decking products. Incredibly strong and dense, the dark mahogany brown wood has an elegant look that resembles the deck of a ship. It is highly durable, even with daily use, and is readily resistant to fire, splintering, and termites. The cost of ironwood is similar to that of redwood or cedar (four to six dollars per square foot), but Ipe lasts longer and often comes with a twenty-five-year warranty. Ironwood is available from most lumberyards. For more on Ipe wood, see the Resources section, page 174.

The house's sloping roof and boxlike shape mimics that of a shed. To promote privacy, the hideaway is located far back from the road and is reached via a wooden footbridge (right). Views of the surrounding valley are enjoyed both indoors and out (opposite).

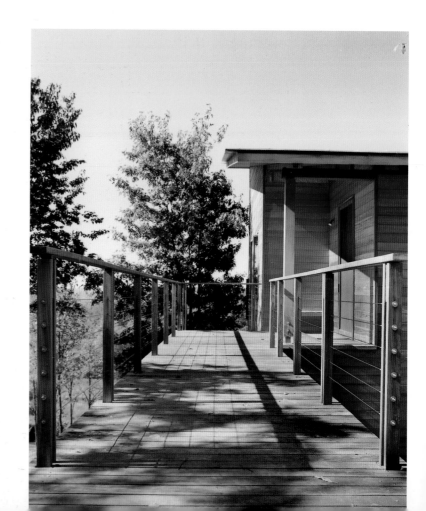

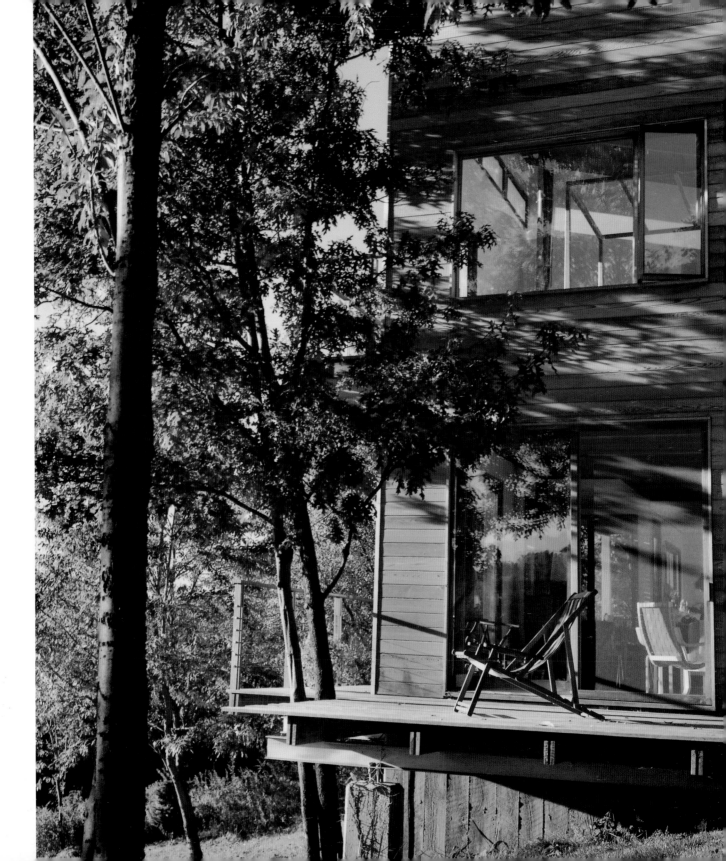

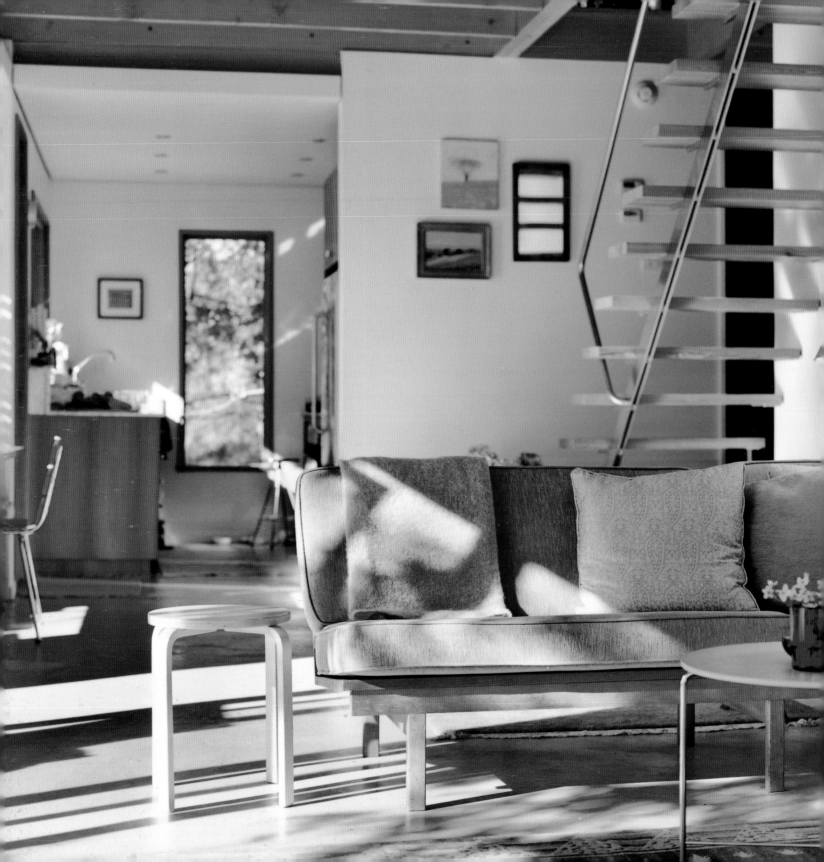

A dining nook (above left and below) that looks onto the deck allows for intimate gatherings at mealtimes.

A modernist aesthetic is seen throughout this light-filled house, where sustainable wood cladding and concrete floors reflect a reverence for unfussy materials. An open staircase of repurposed Douglas fir and stainless steel (above right) joins the living area (opposite) to the second-floor bedrooms.

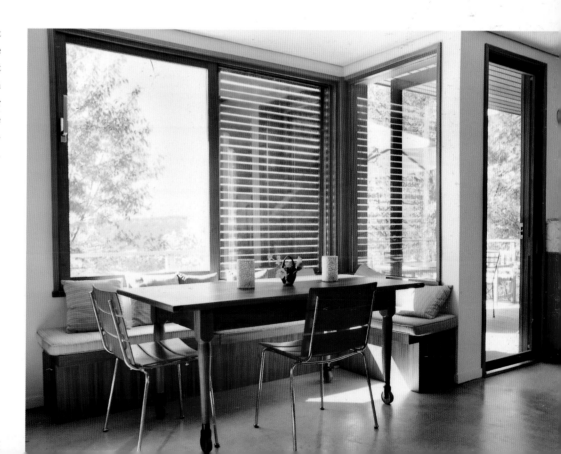

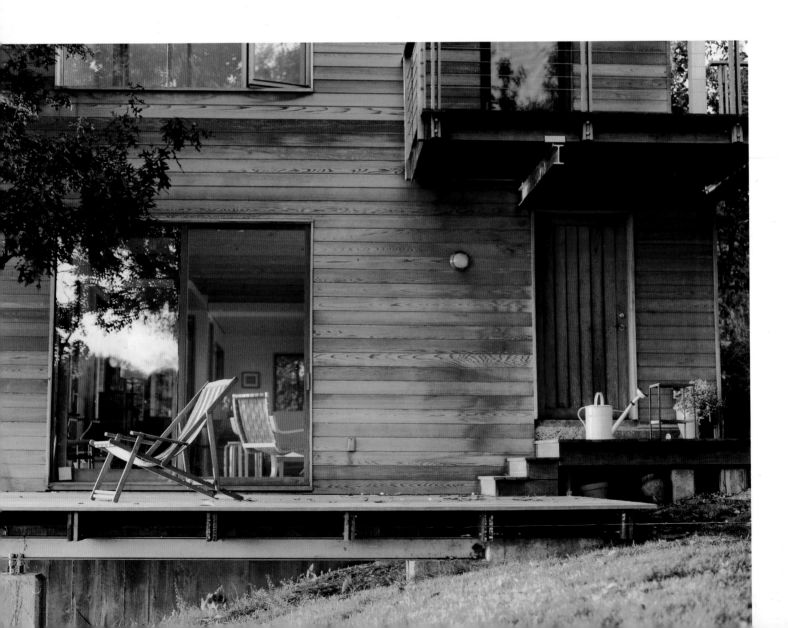

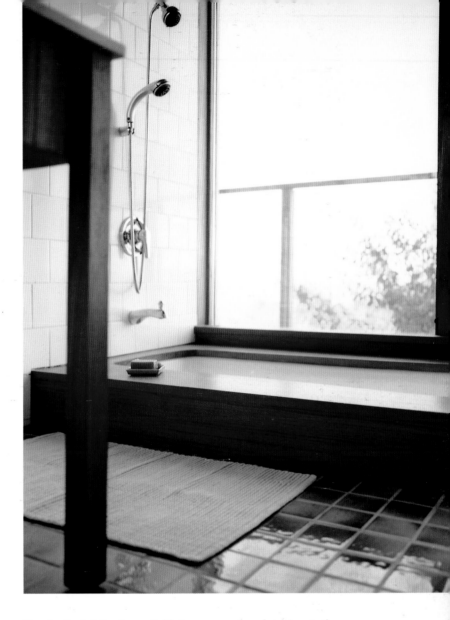

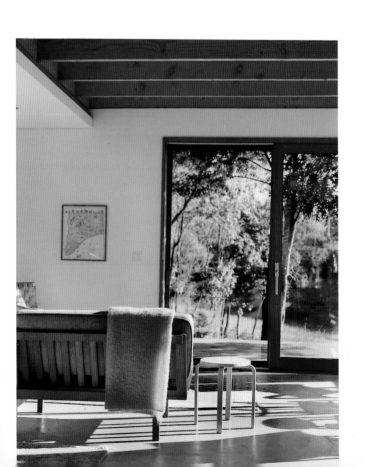

Douglas fir cladding (opposite) brings a warmth and richness to the house, picking up golden rays that bathe the exterior in light. Decks were placed to take full advantage of the views. In the living room (left), a sitting area is oriented outward, making the landscape the centerpiece of the space. Inspired by Japanese bathing, the generous bath (above) features a deep soaking tub ringed with a teak surround. Eight-foot-wide sliding glass windows reveal a dramatic view. Arts and crafts tiles in forest green marry well with the wood and the surroundings.

Artist's Sanctuary

Some retreats were built for contemplation;
this 1840 neoclassical church with soaring ceilings and
graceful stained-glass windows is one of them. The idea
of setting up house in a former church is an inspiring
one—the generosity of space, grand windows, and
hushed feeling within contribute to a restful atmosphere.

It's just the environment you might wish to paint
in, as the owner of this space does. With five thousand
square feet and thirty-foot ceilings, the church offers
plenty of room for working on and storing large canvases.

But there are some practical concerns; the space is
difficult to heat in winter, and although a bathroom had
already been put in, there is only a rudimentary kitchen.
Furnishings are minimal—several large sofas covered
in drop cloths create a central seating area, and a
makeshift bedroom is fashioned from what was once
the choir loft.

The sanctuary boasts a massive pipe organ built
in 1897, as well as original exterior columns and fir
flooring and solid mahogany doors at both ends. The
church is ringed with stained-glass windows, installed
about 1910. The beaux arts designs, abstractions of
classical architectural themes, gleam in the light with
opalescent green and brown tones. The windows give a
warm light, especially beautiful when the sun comes
out. Throughout the day, light moves through the church,
illuminating the canvases within.

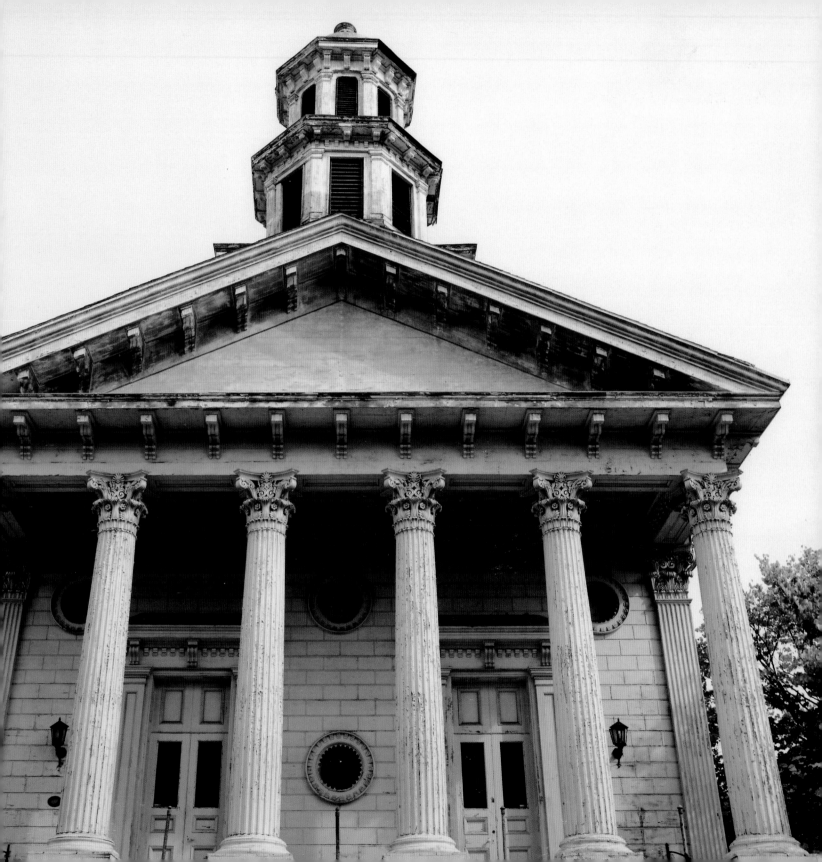

DESIGN DETAIL:
STAINED GLASS

Perhaps the best-known example of exquisite stained glass is at the gothic Chartres Cathedral, in northwest France. The cathedral contains 176 stained-glass windows, the feature for which it is famed. The stained glass was intended to be educational and features depictions of the Virgin Mary, figures from the Old and New Testaments, and the Apocalypse.

Watching the light through the stained-glass windows at Chartres change as the day progresses is a theatrical event, as the character of the glass develops based on the effects of sunlight on the windows. As the sun rises and changes position, certain images come alive, only to recede again at twilight.

A neoclassical church built in 1840, the building retains its original Ionic columns (above right and opposite). Stained glass within the interior (right) brings in warm tones of brown and green and allows sunlight to flood onto the original wood flooring.

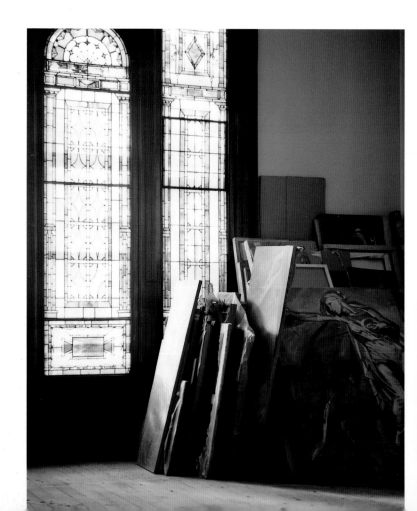

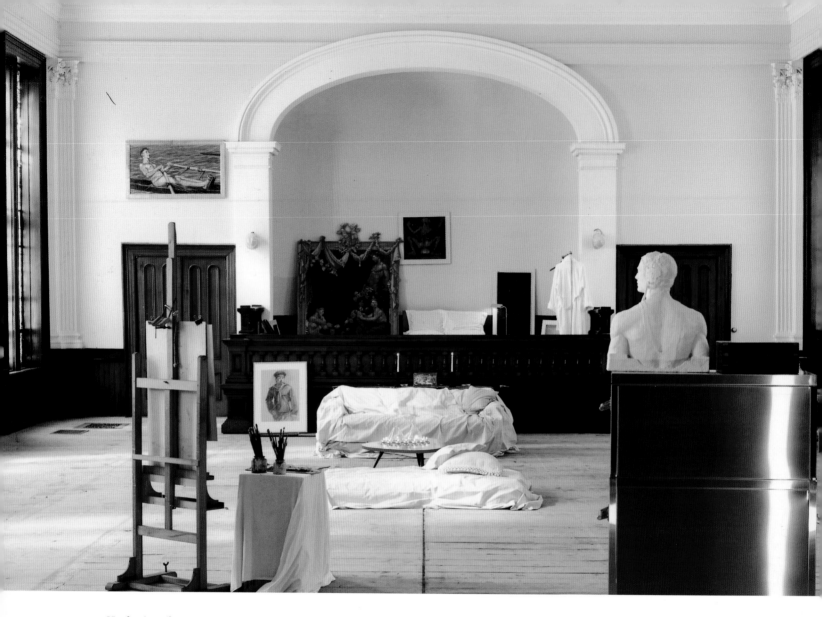

Used primarily as a painting studio, the main room contains very
few furnishings. At the back, a former choir loft was fashioned into
a bedroom from which to take in a view of the majestic room.

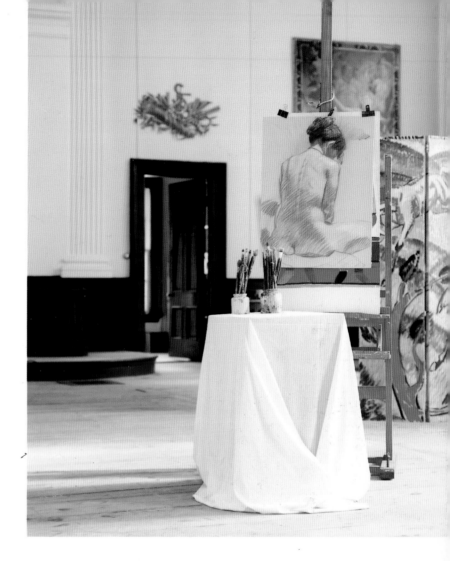

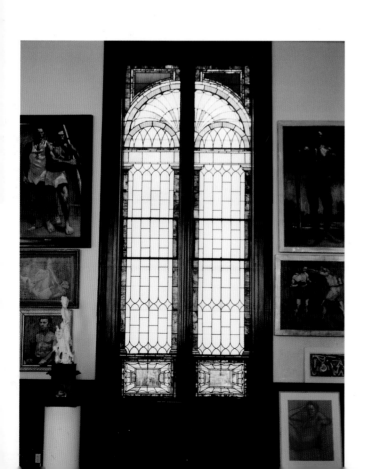

Works in parogress (above) are displayed throughout the cavernous main room, highlighted by sun streaming through the many windows (left).

A cactus garden (above) brings shape and definition to this secluded desert hideaway. Unexpected splashes of color, such as this faded green chair (right), are welcome within the subdued desert landscape palette marked mostly by boulders and sand.

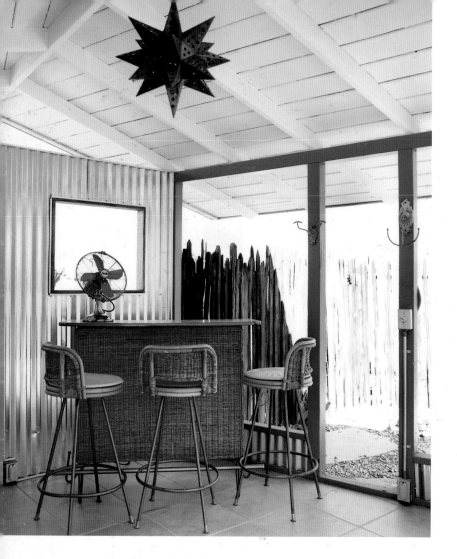

The Tiki bar (above and right) mixes vintage furnishings and industrial materials for a fun, modern look. The tiled floor keeps the area cool; sliding glass doors lead to the kidney-shaped pool beyond. Two red rubber chairs make a colorful statement in the living room (opposite) where a fireplace fashioned of Klondike gold rocks includes storage space on either side of the hearth for extra logs.

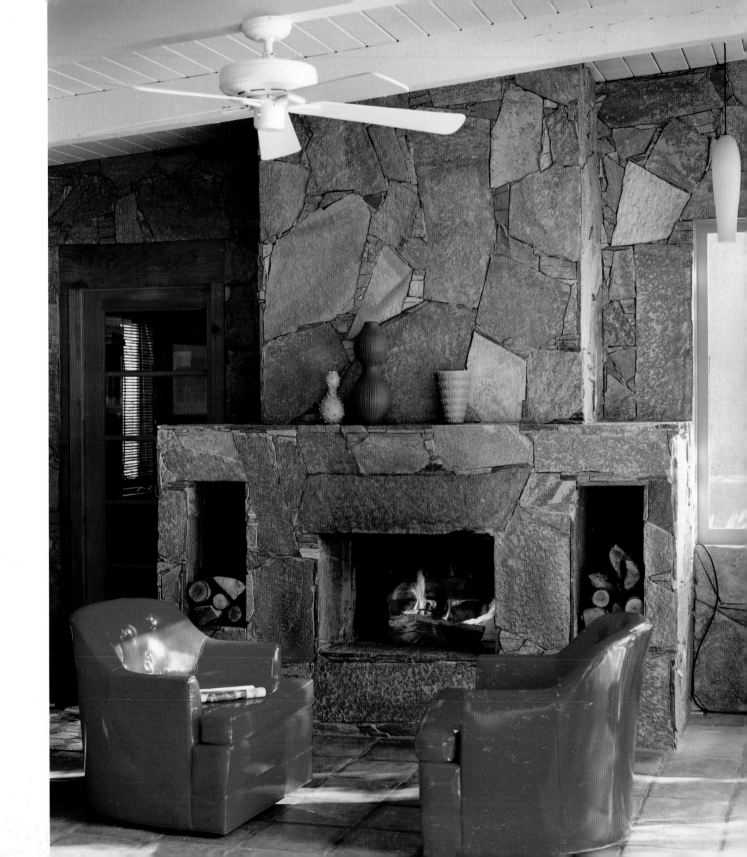

Beautiful tilework is a hallmark of this 1950s getaway: in the bathroom (left) and kitchen (above) terra-cotta tiles in earth tones have a grounding effect.

(opposite, clockwise) A vintage 1950s metal garden chair is at home on the deck of this mid-century house. A lush garden surrounds the pool, creating a secluded spot for sunbathing. Made of wood and corrugated metal, this poolside lounge is at once kitsch and modern. Dry desert air is ideal for hanging fresh linens.

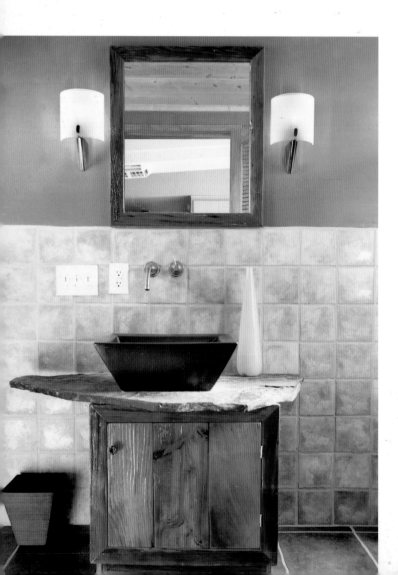

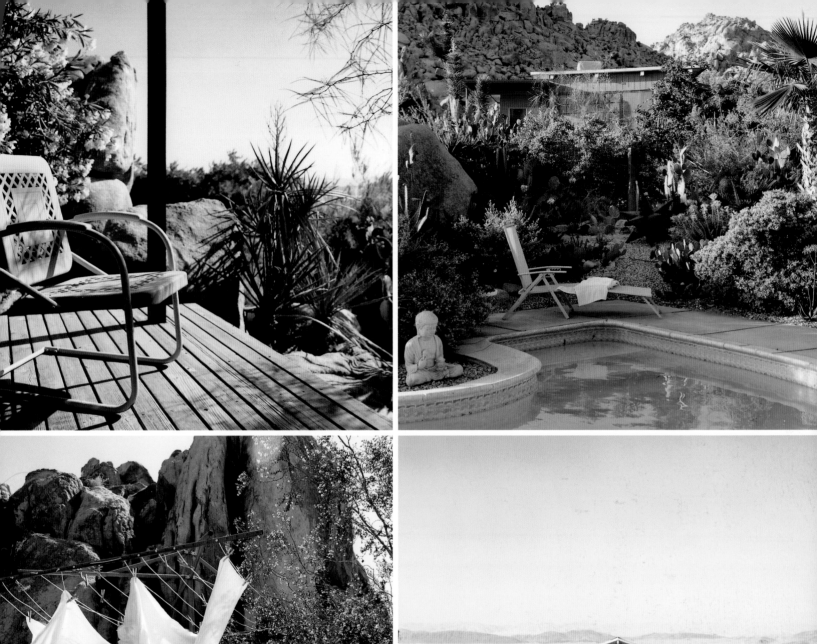
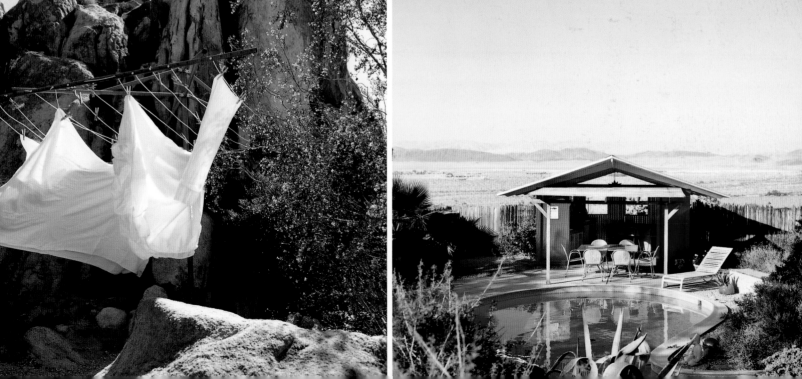

Streamlined Seclusion

that throw subtle shadows, echoing the theme of the surrounding tree trunks.

Large windows define much of the south-facing wall; skylights and transoms above the bedroom doors wash light though the house. Pale maple flooring and mostly white walls amplify the sunny effect; glass jalousies in the bathroom catch light coming in through the living room windows.

Color is used sparingly but to dramatic effect. A large apricot leather couch anchors the living room; brightly colored paintings adorn the walls. A specially commissioned shelf unit serves as both an art piece and storage space. Its panels are colored with primary hues, and some are digitally laminated with photographs. A single wall in the entryway is painted light pink; the fireplace wall is pale green. Colorful accessories—pillows, throws, glassware, and flowers—provide cheerful focal points and add visual texture to the main living space.

Surrounded by thick stands of maple, poplar, ash, hickory, and birch trees, the house enjoys quiet much of the day, save for the gurgling creek. On summer afternoons, it's easy to end up in a hammock by the water, lulled to sleep by the sounds of nature.

Sometimes the best way to embrace nature is to contrast it sharply. Rusticity is often the aesthetic of choice for a country retreat, yet the element of surprise provided by modernist lines can be all the more alluring.

Here, where trees are tall and vertical, the house takes on an opposing horizontal profile that fits the site perfectly. Windows are massive, echoing the water beyond and reflecting the splendor of autumn leaves.

The house is compelling from all angles, a trapezoid-shaped structure with a butterfly roof and no square corners to be found. Clad in hardy board, a concrete composite, the house has vertical battens

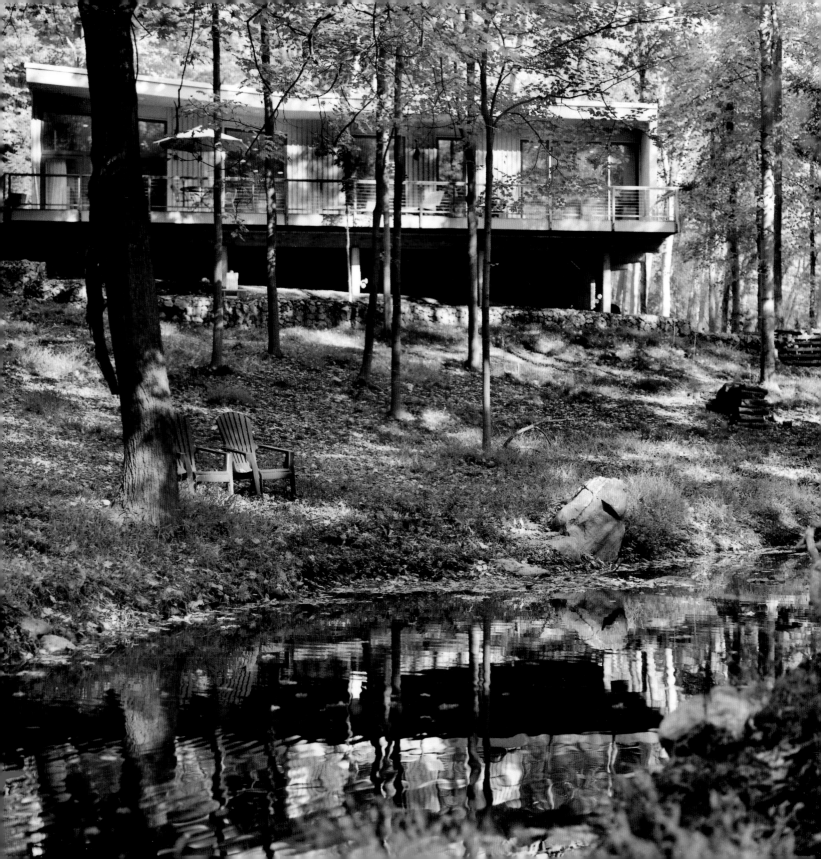

DESIGN DETAILS: COLOR AND TEXTURE

Creating an all-white backdrop for a living space is like working with a fresh canvas, leaving you free to define the space however you like, with plenty of personal touches. Color is a good place to start, and you needn't be restrained. Sometimes bolder hues are more liberating, letting you build on a few daring dashes.

Here, warm hues of apricot, pink, and green set the tone for a lively, cheerful living room that contrasts beautifully with the more subtle earth tones prevailing outside. Use of texture, too, brings life to a room: cashmere blankets, wool pillows, soft rugs, and touches of leather all add depth. The room is rounded out with specially chosen objects in glass, ceramic, or wood to move the eye throughout the area. Finally, artwork focuses attention on specific zones, bringing mood and definition to any room.

(opposite, clockwise) A shelf unit serves as both an art piece and storage; board-and-batten siding adds texture and visual interest to the hardy cladding; soft colorful throws are used throughout the house; the terraced property features a winding stone wall.

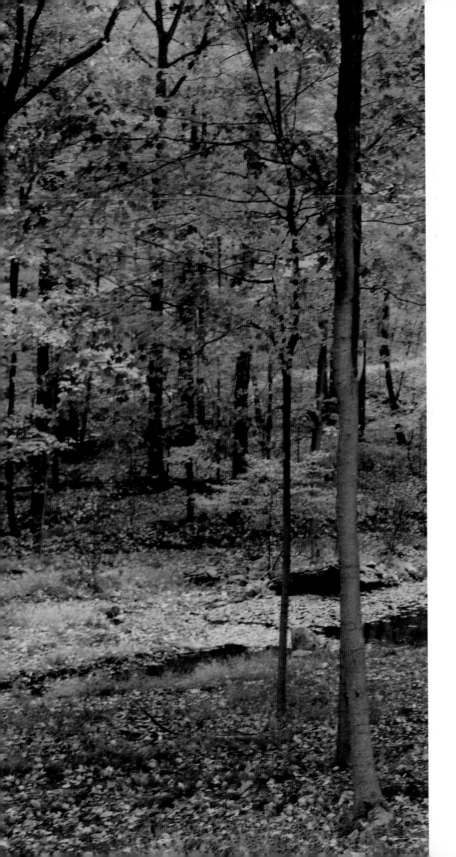

An oversize screen door (above) brings light into the mudroom-entryway; a modern couch in indoor-outdoor plastic greets guests at the door. The sloping property (left) leads to a gurgling creek where the owners often set up a pair of chairs for close-up nature watching.

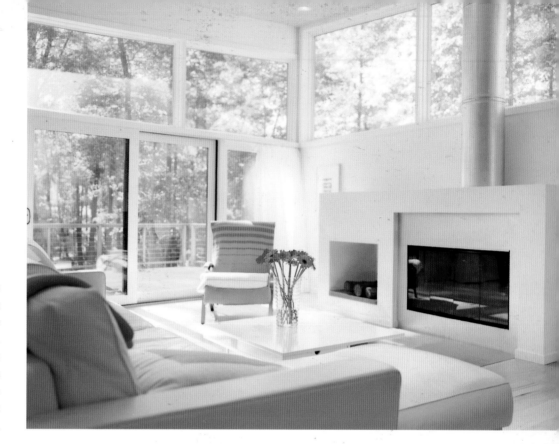

A prefabricated fireplace brings elegance to the streamlined living room (right) where touches of strong color go a long way in the mostly white space. Glass jalousies in the dining area (below) bring light into the house's interior; a modern table from IKEA, along with carefully chosen kitchen accessories, is striking but not obtrusive.

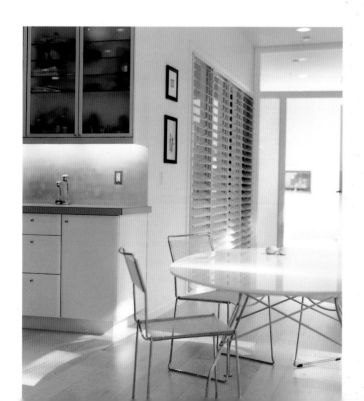

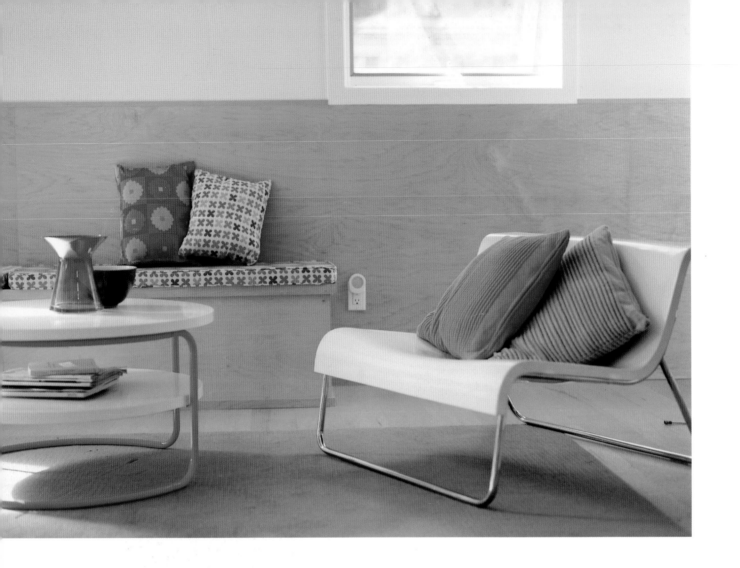

Inexpensive materials were used whenever possible in building this cost-efficient getaway. In the living room (above) a plywood bench is upholstered for extra seating, blending well with the modern furnishings. Colorful vases and bowls (left) bring sculptural forms into play. Light reflects beautifully from the windows (opposite) onto the light maple flooring.

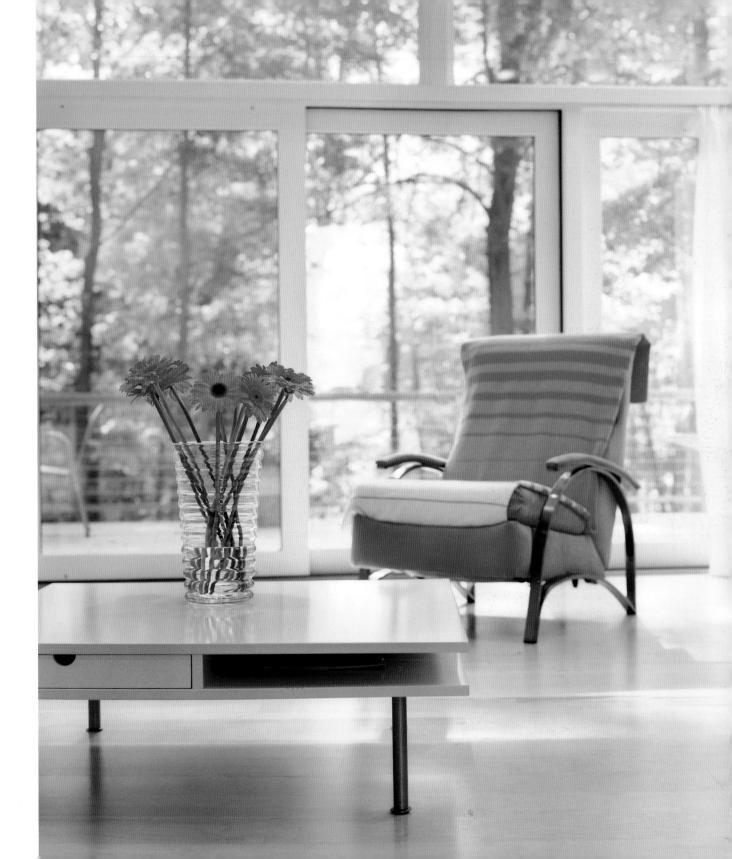

Beach House Retreat

At a beach house, comfort is key. Here, the kitchen is open to friends and family who arrive for the weekend ready to cook—or to kick back with a glass of wine. Furnishings are overstuffed, and windows and doors are open to the deck and the ocean beyond. You can come and go as you please.

Nestled into a snug seaside community, this house is set close to neighboring houses but has a lovely private patio in front enclosed by a wooden fence and gate. The bricks underfoot add a homey feel. Here you can bask in the sun or enjoy lunch alfresco; pruning and puttering also make for delightfully relaxing activities. Dozens of varieties of roses sparkle in the sun, bringing color, fragrance, and buckets of romance to this cozy house.

Within the comfy interior, the open living and kitchen area gets plenty of sun and ocean breezes thanks to two sets of French doors leading outside. Upstairs, a snug sleeping loft feels miles away. At this getaway, it's easy to get lost in the sounds of the sea drifting through the window. Day and night, the hypnotic crash of the waves resonates, soothing cares away.

There is no more calming sound than the rhythmic pound of the ocean. At the beach, worries wash away. Days are spent walking along the water, feeling the sand massage one's feet, watching sandpipers dodge waves and the surf's foam as it spreads across the sand.

The beach is the place to delight in a trashy novel, teach the kids how to build sand castles, hunt for shells. At the shore, time stands still. You can while away hours just feeling the heat melt your muscles and tasting the salty water on your lips. In the evening, it's time to bundle up around a bonfire or dig in to a traditional clambake—and don't forget the ice-cream sandwiches.

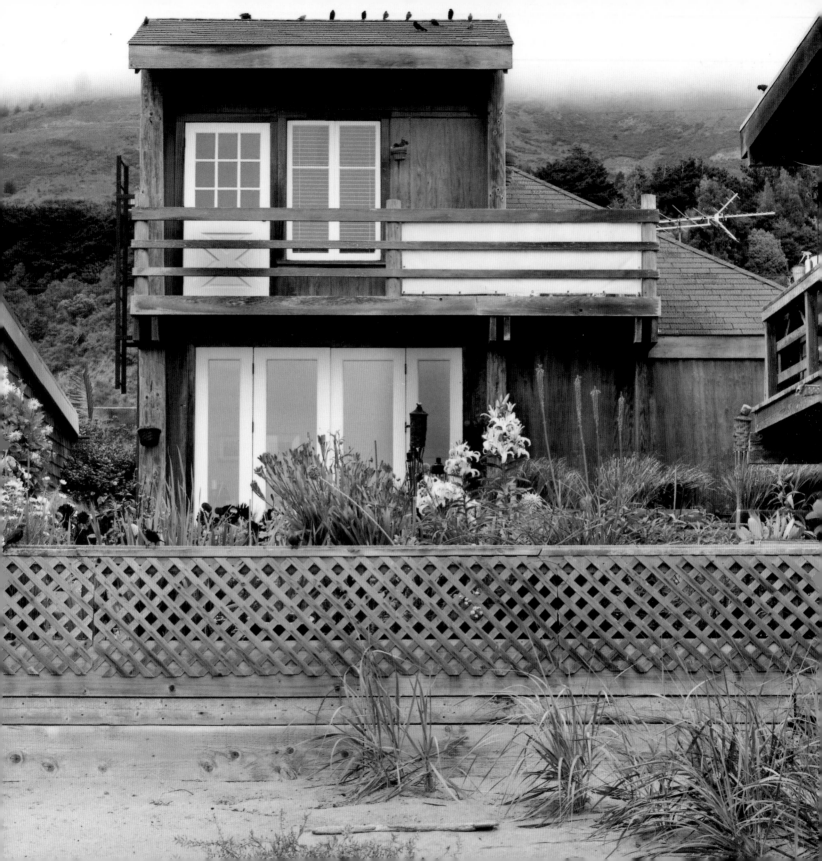

SEASIDE SUPPLIES

By nature, a beach house should be a casual retreat.
To keep things comfortable and carefree, consider
the following:

::: KEEP A GUIDE TO LOCAL TIDES ON HAND

::: IN FURNISHINGS AND ON WALLS, USE LIGHT COLORS
THAT REFLECT SUNLIGHT

::: ALLOW FOR PLENTY OF OUTDOOR SEATING AND
SHADED AREAS

::: USE COLORFUL, WASHABLE RUGS IN ENTRYWAYS AND
HEAVILY TRAFFICKED AREAS

::: KEEP EXTRA SUNSCREEN, HATS, TOWELS, SWIMSUITS,
AND BOOKS ON HAND FOR GUESTS

::: STOCK UP ON BEVERAGES AND SNACKS; KEEP
HAMBURGERS AND HOT DOGS IN THE FREEZER

::: INSTALL AN OUTDOOR SHOWER OR HOSE SO GUESTS
CAN RINSE OFF AFTER BEACHCOMBING

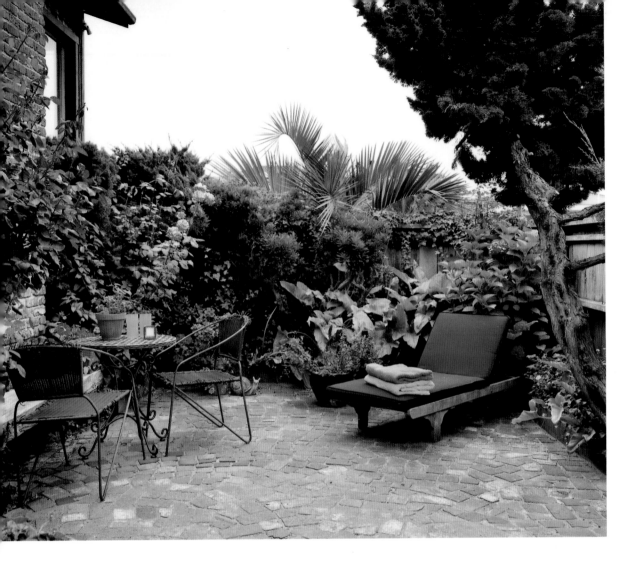

Houses in this tight-knit community are in close proximity to each other, so a private patio (above) is a coveted luxury. Brick-work and lush plantings give the area a welcoming, intimate feel. An old bicycle parked next to a hydrangea tree (right) is the very picture of relaxation.

Sea grasses (opposite) grow easily in this coastal town.

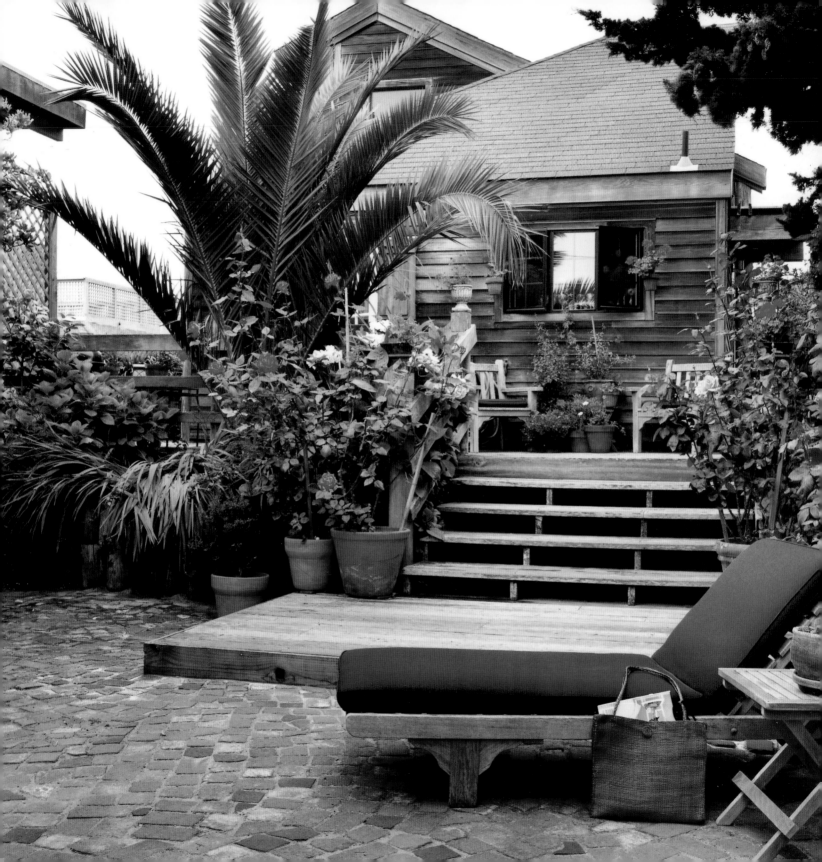

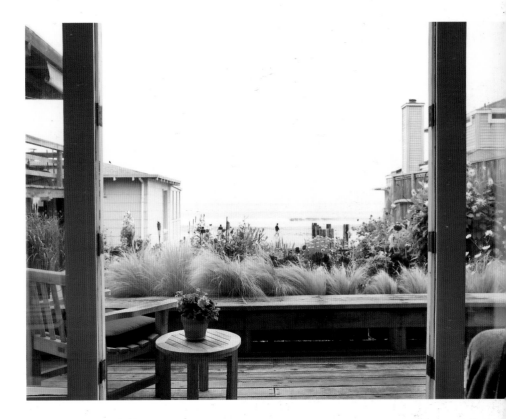

Copious varieties of roses give the entryway (opposite) a cozy, protected feel while adding color and fragrance to the garden. A deck off the living room (above) offers an up-close and personal view of the ocean via a set of French doors; sea grasses and blooming flowers bring texture into the picture.

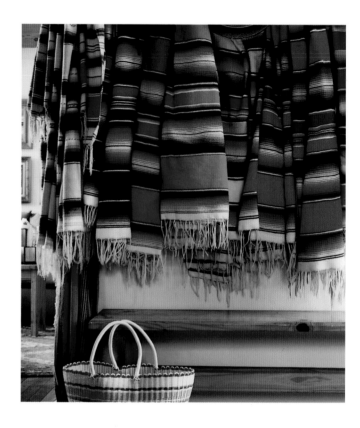

Colorful accessories (above, left and right) create a festive environment indoors. The addition of a small oil painting (left) is a homey touch in the bathroom, adding just the right color spray where needed. In the living room (right) roses from the garden enliven a sitting area.

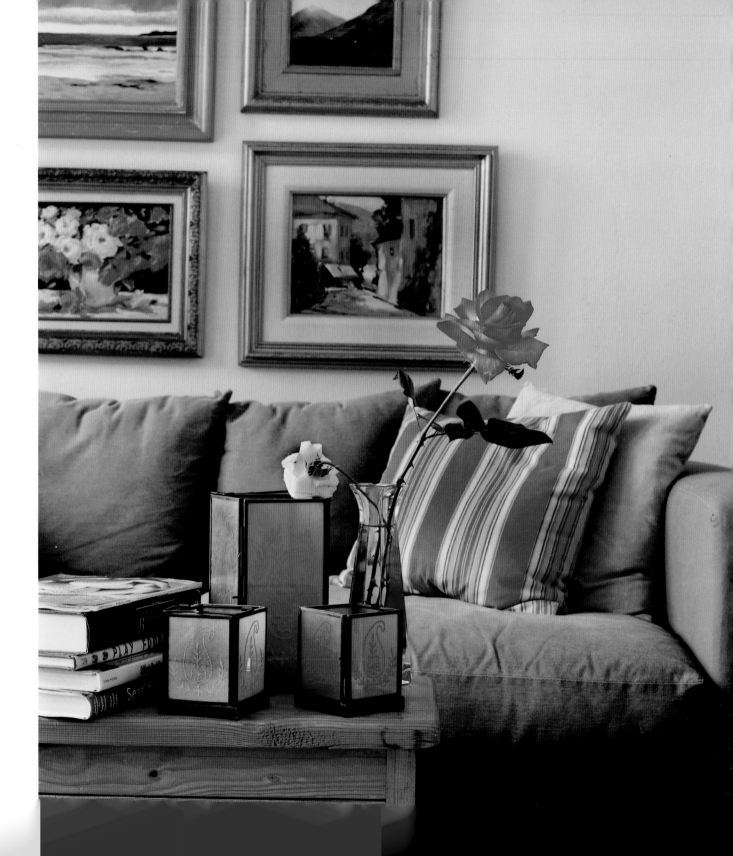

Resources

COUNTRY CABIN PAGE 08

Manka's Inverness Lodge, located in Inverness, California, is one of two locations in *Haven* that are open to the public.

415-669-1034

www.mankas.com

A TASTE OF THE TROPICS PAGE 16

Korakia Pensione, located in Palm Springs, California, is also open to the public.

760-864-6411

www.korakia.com

THE SIMPLE LIFE PAGE 24

The Self-Sufficient Life and How to Live It, by John Seymour and Will Sutherland

www.offgrid.homestead.com

TENT CABIN RETREAT PAGE 32

Sweetwater Bungalows

P.O. Box 9684

Truckee, CA 96162

800-587-5054

www.sweetwaterbungalows.com

PREFAB GETAWAY PAGE 40

Modular Dwellings

www.modulardwellings.com

Glide House

www.glidehouse.com

TREE HOUSE PAGE 48

The Tree House Book, by Peter Nelson

Tree Houses You Can Actually Build, by David Stiles

www.treehouses.com

CREEKSIDE HAVEN PAGE 74

In the Arts & Crafts Style, by Barbara Mayer and Rob Gray

Living in the Arts and Crafts Style: A Home Decorating Workbook, by Charlotte Kelley

The Arts & Crafts Society
www.arts-crafts.com

MEDITERRANEAN STYLE PAGE 84

Photographed at Korakia Pensione;
760-864-6411
www.korakia.com

www.adobebuilder.com

The Owner-Built Adobe House, by Duane G. Newcomb

The Small Adobe House, by Agnesa Reeve

GENTLE GEOMETRY PAGE 110

Although the United States Steel Company officially cautions against the use of Cor-Ten Steel for cladding and siding because of possible corrosion, many cutting-edge architects have embraced its use for decades. For inspiration, visit the Web sites of these famous buildings:

The Ford Foundation Building, New York, New York
Designed by Roche-Dinkeloo
www.greatbuildings.com

The John Deere World Headquarters, Moline, Illinois
Designed by Eero Saarinen
www.deere.com

DESERT MODERN PAGE 118

Desert Living magazine
www.desertlivingmag.com

The Ultimate Desert Handbook, by Mark Johnson

The Desert Home, by Tamara L. Hawkinson

Desert Style, by Mary Whitesides and Matthew Reier

WATERFALL HOUSE PAGE 126

Fallingwater
www.paconserve.org/index-fw1.asp

LETTING LIGHT IN PAGE 134

Ipe Wood
www.ipe-wood.com

NATURAL WONDER PAGE 150

Complete Book of Cacti & Succulents, by Terry Hewitt

Cactus: The Most Beautiful Species and Their Care, by Elisabeth Manke

The Cactus & Succulent Society of America
www.cssainc.org/index.html

Acknowledgments

I would like to thank the owners and designers of the houses featured here for allowing us into their homes. I am also grateful to Geoff di Girolamo, Edgar Blazona, Doug Smith at Korakia Pensione; Margaret Grade at Manka's Inverness Lodge; Jon Kastl and Mark Harbick; Nancy Anding; Mikyla Bruder and Leslie Davisson at Chronicle Books; and, of course, Eric Engleman.

Architecture and Design Credits